Recolle

Eva Neurath
1908–1999

With an afterword by Stephan Feuchtwang

Thames & Hudson

NOTE

From its birth in 1949 for the next half-century
the name of the firm appeared as 'Thames and Hudson'.
It is now 'Thames & Hudson', but in the text of this book
the form has been kept as Eva Neurath knew it.

First published in the United Kingdom in 2016 by Thames & Hudson Ltd,
181A High Holborn, London WC1V 7QX

Recollections © 2016 Thames & Hudson Ltd

British Library cataloguing-in-publication data
A catalogue record for this book is available from the British Library

ISBN 978-0-500-51931-8

To find out about all our publications, please visit
www.thamesandhudson.com
There you can subscribe to our e-newsletter, browse
or download our current catalogue, and buy any titles that are in print.
Printed in China

Contents

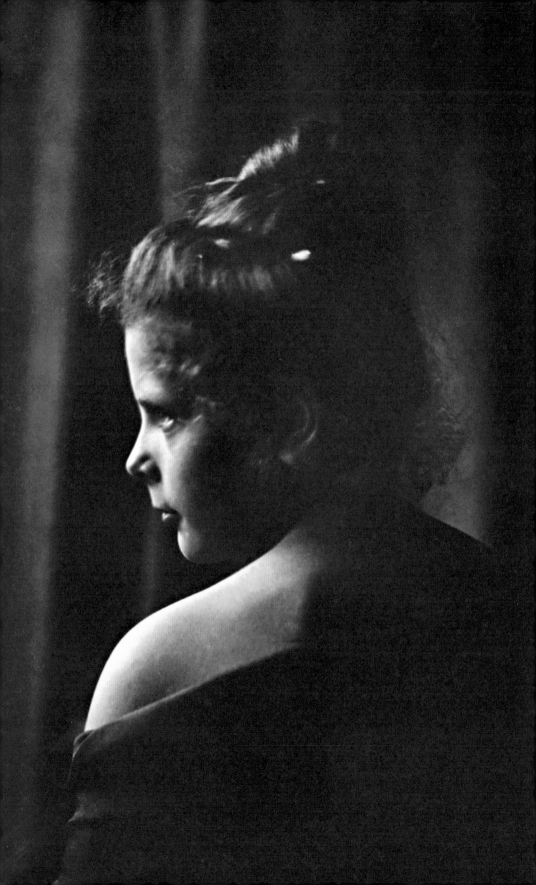

The first nine years

I WAS BORN IN BERLIN-LANKWITZ on 23 August 1908 — or was I? In 1900, also on 23 August, my mother had her first child, and called her Maja Elisabeth. Then came Gudrun Rahel in 1901, and then Charlotte Miriam in 1902, then in 1903 Ingeborg Eva, who died a few weeks afterwards, then Anita Ruth in 1904 — girls, girls, girls! Why there was a four-year gap before I turned up I have no idea, but Maja had wished for a living doll, and dutifully my mother produced it on Maja's birthday — except that I was actually born on 22 August, before midnight. However, I do understand that it is more practical to have two birthdays to celebrate on one day when there are so many little girls to satisfy.

The time into which I was born was alive with conflicting movements. Yet basically it was a proud time. Confidence in their progressive cultural achievements seemed to have pervaded the minds of most Germans, whatever their political affiliations. The *fin de siècle* had just been left behind. The art movement founded then, known as Jugendstil, had tried to overcome the pomposity and overbearing spirit of the Gründerzeit, which in Germany had developed after the successful war against France in the years 1870–71, and as a result of the rich war compensations Germany received from France. Since the middle of the 19th century, Socialism had taken great steps forward under Marx and Engels, and the Socialist party in Germany had achieved considerable strength in parliament, although still under the Kaiser. Imperialism was rampant. All European nations were ambitious and eager to increase their colonial possessions, and hence their industrial and commercial powers. Power at sea was to become a major source of conflict between Germany and England, and this conflict largely contributed to the outbreak of war in 1914.

opposite: A photograph of Eva, almost certainly by Becker & Maas (see p. 22)

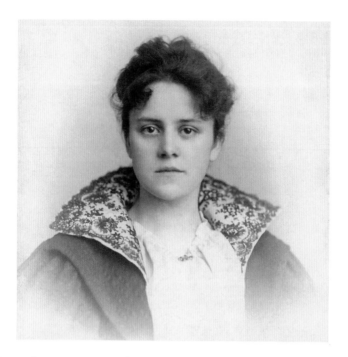

My mother was not exactly a suffragette, but was in every way a fighter for freedom from conventionalism. Her friends were Socialists, and a good many of them had to spend time in prison under the Kaiser. Against the strong objections of her family (she was born Anna Zimmermann) she married a Jew, Rudolf Itzig, who was in the clothing trade. Equality and tolerance, justice, pacifism, all these were ideals for which she lived, and in that spirit brought up her five little girls. Vegetarianism in those days was virtually unheard of; however, we were brought up vegetarian. Every way to health and fitness, so well known these days but quite unknown then, was practised on us. We were put naked under the sun to the shock of our neighbours. I remember that later on I went to school in short socks and sandals right in the middle of winter, while the other girls wore long wool stockings. I came home one day crying, saying that the other mothers cared more for the health of their children than she did, and that I wanted to have long woollen stockings too. She did not pay much attention and said I wasn't going to catch cold – and I didn't.

Around the turn of the century an Indian philosopher, Swami Vivekananda, came to Europe on his way to Chicago to attend the

Eva's mother, Anna Zimmermann, at the age of twenty, before her marriage

World Parliament of Religions. His teachings may have been the source of my mother's love for India, her vegetarianism, her pacifism. Also Friedrich Max Müller, the philologist and Orientalist, must have had a strong influence on her thinking. He prepared an edition of the *Rigveda*, the book of sacred Hindu hymns. She began to learn Sanskrit. It explains perhaps the kind of answers I received to my pestering questions about God. Indeed, along with 'Eva' she gave me the name 'Urvasi', after some Indian half-goddess.

In my earliest years we lived at Viktoriastrasse 4 in Steglitz. I remember the layout of the apartment, on the top floor, very well. It was a typical Berlin apartment. Two large rooms faced the street, and were connected to the back of the flat by a so-called *Berliner Zimmer*, which had a window overlooking the courtyard. From there a corridor led to the bathroom and kitchen, and on to the bedroom of my parents and our nursery.

I must have been a rather lively child, constantly asking questions and pursuing my poor mother wherever she went. I had been standing outside the locked bathroom asking for answers to this, that or the other when our cleaning woman suddenly shouted, '*Kann denn det kleene Aas nich funf minuten seine Schnauze halten!*' (Can't the little pest shut up for five minutes!). I remember also sitting by the window in my mother's bedroom wanting to know who God was, and my mother saying that I should not imagine him with two arms and two legs but like the wind in the trees. I wanted to know whether he had perhaps four legs and four arms, and when she denied that, I flew into a tantrum, hitting the table and shouting, '*Du verdammter lieber Gott, sag endlich wer du bist!*' (You damned dear God, tell me once and for all who you are!).

I recollect in a kind of anxious way – not really surprising – sitting on a sofa at the age of two next to my mother's desk. She had turned to her

left, away from me, to pick up books she needed for correcting manu-
scripts, and I, being jealous of her activity, grabbed that noise-making
pen she had been using; full of joy, I bounced up and down on the sofa,
and accidentally stuck the object of my jealousy into my eye.

I remember very well the position in our nursery of the beds,
cupboards, and window, as well as the door leading to our parents'
bedroom, and I believe this was connected with particular events to do
with my eyes. After having nearly blinded myself with the pen at the age of
two, I now had yet another accident. I was sitting in front of a large bowl
of red peppers, which was standing in front of a floor-to-ceiling mirror

Viktoriastrasse 4 in Berlin-Steglitz

in the salon. I was squeezing the peppers, and when I put my hands up to my eyes it made them itch madly. The more I rubbed them the worse it became. For weeks I had to lie in bed with my eyes bandaged.

I also managed to cut my thumb very badly. My mother had left her Singer sewing machine open (in those days the sewing machine was attached to the top of a table, and lifted up out of it) to go and get some oil. I of course immediately had to examine the machine, and it came crashing down on my thumb. On another occasion, later, I succeeded in flying into our neighbour's garden because I was recklessly swinging too high on my swing!

Two of my sisters had made friends with a family downstairs and were invited for chocolate in the afternoon. When they returned home, the other two wanted to know, 'What does it look like there? How is it furnished – in good taste?' They were all whispering together and I could not really gather what it was about. I heard, 'they are living off their capital!' This seemed to have been something quite dreadful. They sounded deeply shocked!

Every lunchtime two or three poor children that my mother was feeding joined us at the dining table. We thought they were absolutely ghastly.

I was allowed to play in the street with other children, with my *Kreisel*, a spinning top, chasing it along with my whip. Somebody said that I was not going to be in Berlin for long, because my mother was going to move us all away from the city.

In 1912 or 1913, at Christmas, I was in the dining room, but the large sliding doors into the salon were firmly closed. Behind them my mother was putting out the Christmas presents and decorating the tree. I was alone, trying my hardest to peep through the glass panes or keyhole to see what was going on in there. I needed to go to the loo, but couldn't bear the interruption to my spying and so I wet my knickers. My father came in, saying, 'Evchen, what are you doing here?', and sat down in the large red leather armchair. 'Come and sit on my knee', he said. I was terrified, as I'd wet myself. He seemed not to notice, however.

There was always some music. My father liked singing German *Lieder*. One evening we were all sitting in the salon on the golden chairs.

A pianist friend had arrived from America. His name was Arthur Loesser. He went straight to the piano, I presume on my parents' invitation, took the whole thing apart, so it seemed to me, and played with such deafening noise that I have never forgotten it. '*Ein armes Tier ist das Klavier, der Virtuos stürzt sich darauf los, und wie es schrie das arme Vieh*' (The piano is a trusty animal: the virtuoso attacks it, and the trusty beast cries out). It all terrified me.

My Uncle Heinz [Heinrich], my mother's brother, came on a visit. He was much loved by my sisters because he took them out and spoilt them with sweets and lemonades. He had just returned from Mexico. I was not fond of him, because he always enjoyed frightening me. That day however I was full of an acting role. I was made to practise for a play my mother had written in celebration of my father's fiftieth birthday. I hopped around, jumped onto my parents' double bed. Uncle Heinz and my sisters were sitting in a row watching me. I was deeply engrossed in my performance, when suddenly with a wild shout they all jumped up

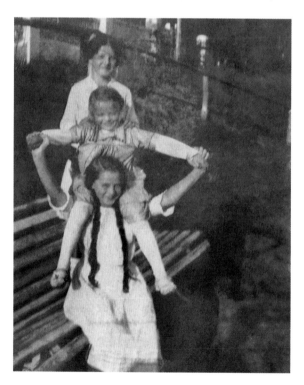

and threw themselves on me shouting, '*Auf sei mit Gebrüll*' (Stop all this noise now). I ended up in hysterical, terrified screams.

When war broke out in 1914, to her great distress my mother found that her own family, as well as her friends, were enthusiastic patriots and eager to serve the nation at war. They were not pacifists. My father was ill, and she decided to leave Berlin for a small, new village not far from Oranienburg, Borgsdorf. She took a villa there in the Diana Allee at the Hubertus See, and that was for us children the beginning of a mainly happy time. The house stood beside a small lake, and behind it was the forest, the Kaiserlich-Königliches Forstrevier, populated by all sorts of animals, who came into our garden. This little village had been built shortly before the war, and in the new war situation the houses stood empty, except for one or two, so we had the whole area to ourselves. My father had had a stroke from which he only partially recovered. He had been sent to a mental institution, where my mother discovered that they beat him. She of course removed him immediately, and brought him home to this new house.

While my sisters took the train every morning from Borgsdorf to Oranienburg two stations away to go to school, I was left alone, and my mother sent me on walks at the hand of my father. I deeply felt his strangeness and it created a lasting impression. My mother, however, seemed not to worry in this respect. He died in 1915, not at home,

opposite: Eva — in the middle — with her sisters Anita (above) and Lotte (below)
above: Eva with Maja in Borgsdorf, probably in 1914

— 13 —

but in a hospital nearby, where my mother had taken him for a short period while she made structural changes to the upper floor of the house. As his mental state deteriorated she wished to accommodate him there, separate from our rooms.

When my father died Uncle Heinz took us all to a large shop, and there on the first floor we were dressed in black mourning from head to toe. These new clothes much excited me. In the house of another uncle a small room was totally filled with flowers. The intense, rather wonderful but overpowering smell is unforgotten. To this day when I enter a florist's that smell comes back. Later my mother took us to say goodbye to our father. We were each taken to him to kiss his forehead – icy cold.

The war years in Borgsdorf were full of problems. Food was rationed, but most people in Germany had some way of getting extra food – from country peasants by bribery, or on the black market. We however were quite isolated and not known in the neighbourhood. With our ration cards we had to walk about an hour to the village, and the route took us through a large wood. I remember the many crows circling above us, squawking and screeching. It made a haunting impression on me, and Schubert's *Lied* 'Die Krähe' from the *Winterreise* always brings it back to me. Whatever food we came home with was never even the full ration to which we were entitled. From time to time Uncle Heinz came and brought something for us. He also went with my sisters to the country to get coal or potatoes or whatever there was from peasants, but that was not often, and so we lived very hungrily on turnips and turnips and turnips. To this day I can't stand the sight or smell of them. My mother, however, had discovered soya beans, and bitter and dreadful as they were, I believe they saved our health. Evidently she conquered the situation without having to resort to obtaining food 'under the counter', or by bribery, to which she objected. But when I caught whooping cough and was quite desperately ill, only one room in the whole house could be heated. My uncle came from Berlin to bring some milk and rice. The plate stood by my bedside for days. My poor sisters hovered around it without being allowed to eat it. In the end, I am glad to say, they got the rice. When I was getting better, my teacher came to visit when we had just had our dinner of turnips – smelly stuff. All the windows were

quickly opened wide, and the poor man had to sit in the icy cold salon. When at last he was taken into the room where I was lying, the cat had shat on my pillow and the smell filled the air. Also in the winter the whole water system was frozen, but there was snow in the garden which my mother melted, and that was our drinking water.

Our nursery was upstairs. No heating was provided. I still see my four sisters, one next to the other, on the two large beds, and myself standing on a little stool, naked, in front of a washbasin full of icy water. These four old girls, or so they seemed to me, were playing '*Kaiser, König, Edelmann*', a game which supposedly reveals who one's future husband would be – emperor, king, or nobleman. They all had the greatest expectations. I am told that I turned to them in my naked state with great disdain and declared haughtily, 'I am going to marry a gardener, a simple citizen.' Well, I didn't succeed.

During the winter the tiled stove in the small living room was alive with coal. In 1916–17 I think this was the only one that was actually in use. These stoves were very cosy, pleasant to look at and efficient. They had an *Ofenrohr* into which apples were put, giving off a wonderful smell, and baked apples were certainly loved by us all.

One winter, it was January, a sunny day, we all went down to the lake which was frozen over. We hacked the ice, got in, but jumped out quickly – the water felt like many sharp knives.

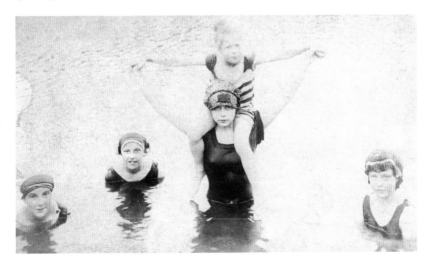

The five sisters in the lake at Borgsdorf, 1916

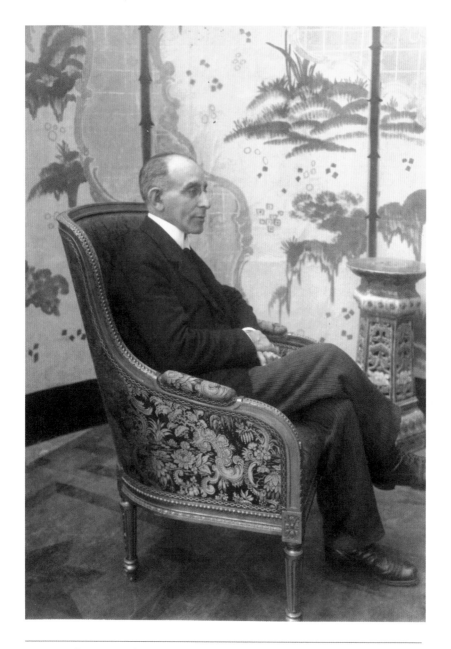

Eva's stepfather, Siegfried Kahn, photographed by Maja in the UFA studios in Tempelhof, on the set of 'Madame Dubarry' — a film by Ernst Lubitsch, released in 1919

Summers in Borgsdorf were wonderful. We wandered into the forest and over the heathland collecting mushrooms and berries, and whatever edible stuff we could find. There was the lake where we went swimming all day long. We were either in the water or among the deer in the forest. In a tree-house built to store hay for the deer in winter, my sisters did their homework. I have been afraid of swans ever since one summer I was playing alone in the back garden when suddenly in waddled two swans. Seeing me, they stretched their necks and chased me around squawking loudly. When I tried to drive them off they came after me again flapping their huge wings.

At some point towards the end of the war somebody had obtained the most unbelievable treasure: a few eggs and some sugar. We five and my cousin Heini, who was staying with us at the time, couldn't decide how to eat them, they were so precious! At last it was decided that we should each put our egg into a soup plate, pour over the sugar, and beat it with a fork. I did this too, but walked away from the others into a corner of the garden. I thought that just eating this was not quite good enough and decided to add luxury to luxury by enjoying my egg while sitting on the swing. It was absolutely delicious, but unfortunately did not stay with me – I got sick! No wonder, after all the years of semi-starvation.

Some business had made my mother go to Berlin where she called on her admiring brother-in-law, Max Battke, who had looked after our financial affairs after my father's death. She left with a huge bunch of red roses in her arm and probably looked very striking, being beautiful and in mourning. She was followed by someone who, just before she boarded the train for Borgsdorf, managed to talk to her. Apparently she gave him a little puzzle, saying that she was on her way to the Diana See, but added no more. A few weeks later, this person turned up in front of our house, identifying it by hearing someone play the piano. He had found out that my mother lived in the Diana *Allee* at the *Hubertus* See. On 3 September 1917 she and Siegfried Kahn were married. What courage on his part to marry a widow with five young girls attached.

Eva in the Twenties

Postwar, the worlds of music and art, and Ernst Jutrosinski

In Russia the Tsar had abdicated and in March 1917 the revolution broke out. On 7 November Kerensky, head of the Menshevik party and prime minister, was overthrown and the Bolsheviks came to power. On 15 December a ceasefire between Russia and Germany was signed at Brest-Litovsk. What was so memorable for me was my mother's intense joy at these events – the end of the hostilities, the end of killing, and the end of the whole horror. However fighting continued in the west: America had entered the war in April 1917, and new ammunition, troops, and anything required were supplied in huge quantities to the Entente. General Foch went over to the offensive, and broke through the German front in August 1918. An armistice was declared on 11 November 1918. Woodrow Wilson, President of the United States, set up a peace programme containing his famous Fourteen Points. These contained requests such as the freedom of the seas, open doors for trade to all nations, disarmament, fair distribution of colonies, the right of all people to their independence, and the establishment of a League of Nations. But other than the League none of these points was included in the Versailles Treaty in June 1919, in particular not those for the minorities. Wilson did not sign the Treaty, under which large parts of the industrial areas of Germany were given to Poland, as were Posen, Danzig and West Prussia. Schleswig was given to Denmark, and the Saar with its coal mines was placed under League of Nations control. Alsace-Lorraine was given to France.

My stepfather was a *Syndikus* or corporate legal representative for several film companies, including Metro-Goldwyn-Mayer, Paramount, and UFA, whose studios were in Berlin-Tempelhof, and in 1918 we left the house in Borgsdorf and moved into a large villa in Tempelhof.

For a child, in fact for anyone, it is an upsetting experience to lose a home with which one totally identified, and to be placed in a new world, different and strange. The house, at Albrechtstrasse 103, was large, with a park-like garden. We once counted all the rooms, my sisters and I, and it came to something like 32 altogether, including the bathrooms, domestic quarters, cellars, etc. The house had been built in 1902, when spaces were designed generously. I was unhappy. Although I was surrounded by a loving family, my sisters were much older and my mother was totally occupied, understandably, with her new husband and new life.

On 9 November 1918 the Kaiser abdicated, and the Republic was proclaimed in Germany. Workers' and soldiers' councils were formed, modelled on Russian examples, representing the Government, the so-called Räterepublik. The scuffle between the Spartacists and the more moderate Social Democrats led to the Spartacist revolt in January 1919. Karl Liebknecht, the radical Social Democrat and head of the so-called Spartakus Bund, and Rosa Luxemburg, also in the leadership of the Bund, were murdered in June 1919 by the Deutsches Freikorps. These two people were greatly admired by my mother, in particular Rosa Luxemburg, who indeed was a most sensitive and poetic writer, whose letters from prison are widely published now and a joy to read. When we moved to Tempelhof my sisters were in their late teens, and only Anita and I attended the Louise-Henriette Lyceum for girls. (We had to walk a long way to school, it seemed to me. Between Albrechtstrasse and the school in Dorfstrasse lay two parks which we had to cross. I think it took about half an hour.) The school was Right-wing, Deutschnational, and great joy was expressed when both these murders were announced. I came home and found my mother, surrounded by my sisters, in violent tears standing by a window. I, however, being innocent and ignorant, cried, 'Mummy, Mummy, hooray! Rosa Luxemburg is dead!' I believe she did not talk to me for weeks. I did not know why; it was a terrible thing.

My name, Itzig, was very conspicuously Jewish, of a kind which in the later years under Hitler's rule would be used to mock a Jew in degrading terms. (The name is actually derived from 'Isaac'.) I was often pursued by hordes of boys shouting, '*Itzig, Itzig, wat se find dat nimmt se mit sich*' (Itzig, Itzig, what she finds, she takes). It was very frightening.

My mother would not have tolerated changing our name and would have despised me for wishing to deny my Jewish father. There was no other school I could go to in the area. The thought that my mother regarded anti-Semitism as a depraved opinion conceived by the scum of the earth gave me some self-protection.

Life went on, but not comfortably. In 1918 an influenza epidemic, the *Grippe*, began to devastate the world; by 1920, 22 million people had died (among them Egon Schiele). This was much more than the death toll of the war, which took 8.5 million lives. A new constitution was drawn up and promulgated at Weimar. The Weimar Republic was established in July 1919. The immense loss of land, industry and trade led to widespread unemployment that invaded social life. Inflation was rampant. The 5 billion dollars in reparations Germany was made to pay to the victorious powers gave her no chance to restore her economy. By 1923 inflation reached such heights that one US dollar was the equivalent of 4.2 billion marks. Unemployment having first affected the working classes now devastated the middle classes, who lost all their securities, pensions, savings, insurances. Everything went bust, everything became valueless. Something like three times a day salaries were paid out and people rushed to buy provisions and other goods because within hours the money was no longer sufficient for the object. As so often, however, one survived. The introduction in 1923 of the *Rentenmark*, replaced in 1924 by the *Reichsmark*, brought an end to this economic chaos.

Food and everything was short in these years, and we children were each made responsible for our own consumption of bread – one small loaf, which we had to make last for the whole week; if we ate it up too quickly, we went without until the next week. In spite of all that, the house was frequently full of visitors. I can't imagine how my mother managed. The long table in

Eva in a dirndl, in the garden

the panelled dining room was laid very nicely, but food was sparse. I think some people even brought some of their own. Hungry as we all were, we nevertheless lacked the courage – I vividly remember such an occasion – to pick up a last slice of salami, looking lonely on a large plate. But who indeed could have done such a thing with so many others at the table.

My mother and her little girls were popular with a well-known photographic studio, Becker & Maas. There we got photographed lying naked on rugs, or in bed, or fashionably dressed. When I was about ten years old they wanted me to model children's dresses, and so I appeared in the newspaper. Our history teacher, Miss Fleming, who we much disliked, saw this. She mocked me endlessly, made ironical, cutting remarks, and ordered me around. 'You are not here as a ballet dancer or a dress model. Stand up straight!'

A few years later, when I was about fourteen, it was she who we locked up in the classroom. A girl from another class was free during our history lesson and we instructed her to take the key of the door and lock it from outside shortly before the bell rang. We gave her the agreed signal: a girl in the first section of the class said 'Ha!', followed by the second saying 'Ha ha!' and then the third who said 'Ha ha ha!', whereupon the whole class shouted 'Ha ha ha!'. In that noise you could not hear a key being turned. Our teacher was outraged and stormed to the door, which had been locked. She returned to her seat in stunned silence. The whole class was locked in with her. I can't quite recall how the door was opened. I suppose some other teacher got the porter to do it. We were overjoyed with our success. Our form teacher, a jovial person, who taught us Latin, said that he quite understood – he had done similar things when he was at school – but what mattered was not to get caught. Of course we were stupid and did it again. This time the girl outside, in her terror, threw the key out of the window into the wheat field. The game was up, and there was a great hullaballoo. Parents complained, newspapers reported on it, and finally we were subjected to a formal session in the aula with the whole school in attendance. Two of the girls were dismissed from school. I escaped this punishment, but when my mother heard about it all she was upset and outraged by what she saw as the stupidity of the teacher's behaviour. She thought that such a school was not good enough

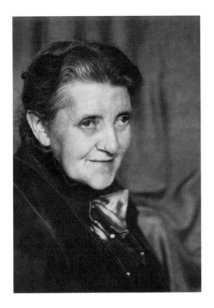

for her daughter, and she asked me whether I would not rather leave. Out of loyalty to the girls who were dismissed, I said yes, and never saw a school again.

My mother's parents came from Forst (Lausitz) – now almost in Poland. They had four children: two sons, Heinz and Karl, and two daughters, Anna (my mother) and Ada. My grandfather, Fritz Zimmermann, was a brewer, but not a good businessman, and at some stage the business was dissolved because he had 'guaranteed' it to a friend. After having twice been a soldier his health had suffered, and at the relatively young age of fifty-five he died. My grandmother, whose maiden name was Anna Wagner, started to work. She became a leading member of the Lette-Haus, the first or at least one of the early adult education institutions in Berlin, and for a number of years was the editor of their magazine. Later she worked as secretary at the Botanical Gardens in Berlin, which had just opened. She left us an extensive chronicle of our family starting in 1785, going right through to the 20th century. The Wagner family considered themselves, rightly or wrongly, to be related to the composer. The chronicle makes interesting reading, giving detailed descriptions of family life in a small town like Forst. It appears that most of the families with whom they associated were cloth manufacturers, like themselves, and were all house-owners, which enhanced their status in society.

While we were in Tempelhof my grandmother came to live with us. She occupied the attic rooms. At first my stepfather had refused to tolerate her in the house – an old woman, he said, brings bad luck. However, she was happy. Her sight had become too weak for reading. Whenever I passed by her door I heard her voice, reciting to herself – the Bible, poetry, and lots more. She knew it all by heart. These fortunate people

Anna Wagner Zimmermann, Eva's grandmother: a photograph inscribed to her grandson Heini, Christmas 1923

in their school days had learnt to memorize their literature, and indeed nothing is better for training the mind.

Around the turn of the century in Germany a youth movement, the Wandervogel, had begun to take roots. In Munich a magazine called *Jugend* had been published since 1896, which concerned the new art movement known as Jugendstil (or Art Nouveau), an international movement much influenced by the English artists Aubrey Beardsley and William Morris. The ideas behind the Wandervogel movement were a reaction against the overbearing authority of 19th-century parents. Young people wanted to be free and self-reliant. They believed in the 'back to nature' philosophy, back to truth. They revived folklore, folk dancing, and folk songs. They went on long rambling walks and in the course of the years *Jugendherbergen* (youth hostels) were founded everywhere. They had guitars, sang songs, and wished to dissociate themselves from the bourgeois culture of their parents.

We at home were not associated with these ideas. However, a strong influence came from my uncle Max Battke, husband of my aunt Ada. He was a professor of music and a composer, and had founded the

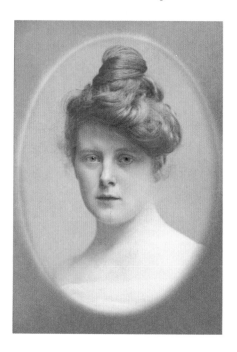

Aunt Ada

Berliner Lauten Chor. A then famous poet, Hermann Löns, had been killed in September 1914, and became a great hero for young people. Max Battke set his poetry to music, and these songs were sung, and performed by his choir, right through the war in military hospitals and concert halls. We were living in Borgsdorf at the time and sang his songs with equal devotion and enthusiasm. We also went for long walks singing and whistling, to the accompaniment of a lute. Of classical music I remember in particular passages from Schubert's *Trout* Quintet and Brahms's violin concerto.

The whole Zimmermann family loved writing – stories, poems, whatever. Tante Ada produced much poetry, though only a little was published. The Battke family consisted of Ada, Max, and their sons Fritz and Heinz. Before the war they lived in great style. Ada Battke was a celebrated beauty, and Max as a musician was closely involved with the musical and intellectual life of Berlin. When war broke out, however, Ada, like so many others, ignored her former ideals and supported the war effort with great fervour. Fritz, her eldest son, was too young to be drafted, and volunteered for the army. She herself became a nurse and worked in hospitals. When Fritz came home on leave my sister Lotte remembers hearing him in the room next to hers crying desperately. The experience in the trenches had been harrowing, and he was probably pleading not to be forced to go back. But there was no way out. He was killed shortly after.

The early years after the end of the war were full of problems. The fighting between the Left-wing Spartakus Bund and the army, the lack of food, and the shortage of goods all round caused much despair and social unrest. Strikes made life a misery. Gas and electricity were there one day and not the next. One got used to it, '*wie der Hund an die Flöhe*' – like a dog to its fleas. Often we had to sit in the large kitchen, because it was lit by gas. We were all young, including my mother, and took it lightly, singing songs for our entertainment as usual.

Fritz Battke, Ada and Max's son, at the Lockstedt Army Camp in April 1917. He was killed on 1 June.

One day I had come home from the UFA film studios with a little Alsatian puppy that they had given me. I had dragged him along the streets for about 45 minutes, flat on all fours, leaving a trail of wet all the way behind him. I should indeed have picked him up, but I was too proud of having a dog on a leash. When I came into our front garden and walked round the house to the kitchen where all the family were gathered, I let him loose. He disappeared at once. We searched and searched but couldn't find him. One evening I was sent to the baker's, and on my return I found everyone in a state of wild excitement. The dog had suddenly appeared from wherever he had been hiding and was barking! He had sensed me coming when I was still in the front garden – clever dog! His name was Rep.

The frequent electricity strikes caused me often to do my homework in the music room where Anita practised the piano for hours every day. I took my history book into a corner and tried to concentrate. For years later at a certain passage, say, of Chopin, I would automatically think, 'Frederick I, crowned in Königsberg 1701'.

In spite of the difficult times we were living in, my parents did not hesitate to entertain their friends. Those I remember best were Ernst Lubitsch and his great star at that time, Pola Negri. There were parties in the garden (which was also used for filming). Pola, with her whole Polish

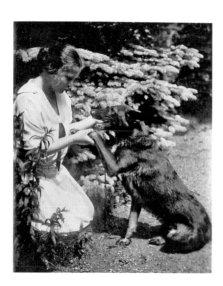

heart, attached herself deeply to my mother and wished to be adopted as a sixth daughter. I did not take to her at all. Sometimes she danced, rushing up and down the music room with veils around her and looking strange. I asked my mother why she had such darkly coloured eyelids. Instead of saying that she had make-up on, my mother said that she was just very tired from dancing and acting. Pola also had the nasty habit of making fun of me.

Eva and Rep in the Tempelhof garden

She was sitting at the head of the table which seated some twenty-four people, and I was right at the other end. They must have been talking about her beautiful teeth, white like pearls. I, however, had a large gap between my front teeth. It did not flatter my self-esteem. When I was sent to bed, I had to go around doing curtseys to each guest, as was the custom for a little girl. I did not curtsey to Pola. When I came to my stepfather he pinched my behind, in friendliness, I suppose. I hated it and ran off.

Every day I had to meet my stepfather at the film studios, which were close to my school. I often had to wait a long time. Naturally I wandered around the film sets, and frequently found myself being grabbed to join in crowd scenes. I remember a charming little village with a fountain in the centre, where I and other children had to dance, 'gracefully please', around the fountain. A very blonde actress was the heroine. Her name was Ossi Oswalda. I think it was on that occasion that I was presented with the puppy Rep as a reward.

I was my stepfather's favourite, I believe, and had the rather tedious duty when he was repairing things to be in attendance. Very tiring it was standing for hours holding his ladder while he worked on the window blinds, or I had to be with him in his workroom in the basement. Naturally I could think of more amusing occupations. But still, I was fond of him. When I was about thirteen he became very strict on my being at home no later than 7 o'clock in the evening. My friend Helga had some worries, and I stayed out later than 7. As I came upstairs, my stepfather opened his study door and demanded to know where I had been. 'With Helga', I said. He slapped my face and shouted, 'Don't lie!' Never before had I been hit. I was outraged. Slamming his studio door behind me I rushed to my room and cried madly, 'Never shall I speak to him again'.

It probably happened more frequently than I was aware of that he had little affairs outside marriage. Apparently he had made advances to one of our maids, and defended himself saying, '*Man wird sich doch wohl noch einen kleinen Scherz erlauben dürfen*' – 'What's all the fuss about? One should be allowed a little fun.' My stepfather and my mother separated.

My mother unfortunately suffered a great deal during her married life, and had tried once or twice to commit suicide. Maybe she should have been more tolerant. But when my stepfather had a stroke and was

left partly lame, my mother, I can only say of course, took him back. In everyday communications he couldn't express the simplest things. The UFA did not stop telephoning, however, asking for information about corporate matters and contracts, and to my amazement I saw him in the hall at the telephone, reciting long paragraphs from contracts.

The most important and most longed-for time of the year was Christmas. In the music room was a tree reaching from floor to ceiling. It was decorated with little red apples which we had to polish, and tie little strings to their stalks. Wax candles, yellow as honey, were put in candle-holders on the tree, and silver lametta was hung in long streaks from the branches. It was a wonderful sight. The thick candles that smelled like honey combined with the apples and the fir tree to create the most ravishing scent. On Christmas eve the whole household – mother, stepfather, grandmother, gardener, maids, and us – were at long last, usually very late, allowed into the room, where we stood in awe of this living tree. Anita played 'Stille Nacht' and other carols and we all sang. Our presents were waiting. We all had places on the huge round library table, and at long last we were let loose on them. I loved most the plate we each got filled with honeycakes, nuts and marzipan. It must have been 11 or 12 o'clock before we sat down to a small meal, usually potato salad and *Würstchen*. The meal ended with something I have not eaten since, *Mohnpielen* – a dish of poppy seed, soaked for at least twenty-four hours in milk and then served with nuts and raisins and sugar. This was a traditional dish from my grandmother's home country, Schlesien. Weeks before, during Advent, we lived in great expectation. As money was not readily available, we had to make our presents. We bought little wooden boxes onto which we burned patterns, flowers or names with a hot metal rod, or we made potholders. Anita was good at crocheting. Maja, planning to study photography, produced photographic albums. Runi, who was going to study applied art at the Kunstgewerbeschule, painted something. The traditional meal on Christmas day was goose stuffed with apples, and it was often as late as 5 o'clock before we got up from table.

With great frequency in our household the maids came and went, so we often had to do the washing-up ourselves, and we made it pleasanter by singing canons. I don't know why our maids changed so often,

except for one occasion. Following my mother around from upstairs to downstairs I heard her scolding voice, calling 'Margaret' from the kitchen to the ironing room and the washing room, and so it went on until she came to Margaret's own room, when her loud voice suddenly stopped. Total silence. Then came a long 'What!' When she had opened the door a man in a short shirt had jumped out of bed and stood in front of her half naked, but in strict military fashion. That evidently was the end of Margaret. She had to pack and go. So we had to do the washing-up again.

Actually, my mother was most free and liberal in conventional matters. Our young friends adored her, and confided their love affairs to her. They could talk to her about matters which they would never have dreamed of talking about to their own parents. There is always a difference between one's own children and others a little further removed. It would not be fair, though, to say that she was not understanding when we had problems. But then I at least did not talk much to her about mine.

Maja, after having finished her photographic apprenticeship in Kiel, returned to Berlin and took what must have been her first job, as secretary to the recently retired Under Secretary of State for Culture, Heinrich Schulz. He was an old friend, an ardent Socialist, who had served time in prison, yet he had also supported the war. Now he had set up a non-profit-making establishment called 'Die Deutsche Kunstgemeinschaft'. Its offices were in the beautiful Baroque courtyard of the Berlin Schloss, designed by Schlüter. The Gemeinschaft held exhibitions of artists' works in painting and sculpture and offered them for sale to the general public, who could pay in twelve monthly instalments. The artist, however, received the full price immediately. This was a great Socialist idea. I worked there for about a year. Probably in the end money ran out, caused by the long gaps between paying the artist and receiving the money from the purchaser, and the association closed down. Maja married Heinrich Schulz, in spite of the difference in their ages of some thirty years.

To give us some food support in those hungry years of the 1920s, it was decided to keep chickens for their eggs. The garden had a little stone house with space under the roof for pigeons. I used to climb up there to do my homework. The chickens were kept below, and allowed to roam the garden. Rep, in his puppy state, was fascinated by them.

One day a neighbour telephoned to tell us that she had seen our dog holding a chicken by its head and shaking it to and fro. My mother, in great uproar, rushed into the garden and rescued the poor chicken. With the bird in a basket she took a taxi to the vet, who told her that the chicken had concussion of the brain. It could be operated on if she so wished, but he recommended her to enjoy a good meal. That was too much for my mother. She gave the chicken to Frau Ebeling, a woman who helped in the kitchen and lived next door. Her daughter, Erna, was my best friend. The following Sunday I was invited there for dinner!

One day when I came home from school noisy voices seemed to fill the house. Agnes, a lively, extroverted, rather beautiful woman, daughter of Heinrich Schulz, had come to lunch. In the winter garden, where during the summer we often had our meals, she was telling stories, and everybody was laughing their heads off. I complained of not feeling well, and my mother put me on the sofa in the living room, near the winter garden. I felt drowsy, and unhappy. When my mother came to look for me I had a high temperature, and diphtheria was diagnosed. I was desperately ill for weeks. In those days there was no penicillin or antibiotics, and an operation, a very risky thing then, seemed unavoidable. However, it ended well. I recall, in the room to which a large

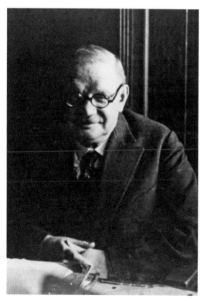

terrace was attached, dancing a polka with my stepfather, while I held on to his trousers which were about to slip, and we both sang, 'Ganz ohne Weiber geht die Schose nicht, Ganz ohne Eva hält die Hose nicht' (Without a wife, things don't work at all. Without Eva, trousers don't stay up at all).

I often spent the summer holidays of some eight weeks at my aunt and uncle's. Dr Karl Hallbauer was a patent solicitor. Their delightful villa in Lichterfelde, much in the 1910 style, had been designed

Dr Karl Hallbauer, c. 1931

by them. Asta and Dankmar, their two children, were much older than I but we all went for long, jolly bicycle rides, me on the tandem with my uncle. He did the hard work and I just sat behind him, until at some lake or forest we had our picnic. His wife, my aunt Martha – my father's sister – died in 1921 and Uncle Karl felt lost and lonely. And so it came about I presume that he wished to adopt me. My mother gently put the question to me. It upset me very much, and I replied, 'Never'.

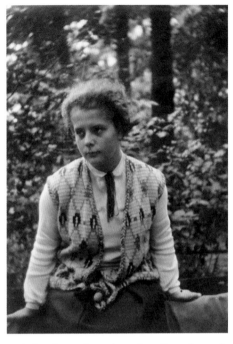

After I left school things seemed alright at first, but then I got bored. I begged to be sent to another school, but fees had to be paid which were high, and with no money around this may be why I never went back to any school. My stepfather seemed to use his money for other things and only sporadically supported the household. My mother gave me a programme for adult education study at the Volkshochschule. I did a bit of French, a bit of art history, and a bit of this and that. After a year I became so unhappy – I was probably fifteen years old then – that my sister Runi took pity on me and I was taken to her office at L. R. Baitz to do some filing of their correspondence. I thought it unbearably dull and begged my mother to send me to the Reimann-Schule, which was then the best school for art and design. But again there was no money, and my stepfather suggested I should learn carpentry instead. I did not accept – it seemed too tough – odd! He came up with a better idea: I should work as a volunteer for Paul Graupe, an antiquarian bookseller and auctioneer.

Graupe's offices were in the Lützowstrasse. He took in collections which had to be catalogued, and each book checked for missing pages and general condition. When auctions were held the system was as follows:

Eva in the woods

the partition doors between front room and back room were taken out so that a long large room was created, and at the end Herr Graupe and his assistants sat on a high platform. It was my task to stand between these two rooms, and should it become evident either by his expression or by other signs that the bidder was not known to him, I had to go and give them a piece of paper on which to write their name and address. The room was thick with smoke, and when I had to give my little piece of paper to a person in the middle of a row, these men had the habit of touching me or pinching me. Altogether it was a very tiring job standing there for hours on end. One day, feeling unwell, I asked a colleague to take my place. I went out on the balcony for some fresh air and after a while came back. At the end of the auction Herr Graupe ordered me to his room. I supposed that the sales had not been satisfactory. However, I was standing at his door when he told me that I need not come back the next day, that his business was not a kindergarden, and that I had failed at my job, not being at my place between those doors. Whatever I said in reply was simply not accepted. So for the second time in my young years I was expelled.

A colleague took pity on me in my shocked crying state and accompanied me home to Tempelhof, walking all the way there from the Lützowstrasse. I found my mother in the kitchen downstairs and with great sobs told her what had happened. She rushed upstairs to my stepfather and told him of this outrage. He picked up the telephone and spoke to his brother, who was Paul Graupe's banker, and in no uncertain terms told him of the ruthless treatment I had been given. But in those days bosses could do what they liked, and there was practically no protection for employees. I thought I would never find another job in my life. (Eventually, Graupe was to ask me back.)

After weeks of searching through the advertisements I came across one that seemed promising. It was a small gallery dealing with old prints and drawings. I had to present myself in their office in the Behrenstrasse. A small, fragile, elderly man asked me friendly questions: Could I write shorthand? Type? Bookkeeping? 'Oh yes!', I said. I was told to start in four weeks' time. I was then sixteen years old. I signed up for a course in shorthand, tried my best at the typewriter, and asked my mother to teach me the basic rules of bookkeeping. In spite of all my anxiety it seemed

at first that I did alright, but one day, reading my letter, Mr Rosenberg remarked that my typing was just as unreadable as my handwriting. It was an old-fashioned office with a very heavy copier. One's letter had to be put between the wet pages of a volume, put under the press, and then the handle was pushed down hard. Actually, it was quite practical. Everything was in chronological order and one didn't have to file things. I learned a lot there and we became great friends. Mr Rosenberg and his wife, who worked with him, always took a two-hour lunch break, and wondered what I was doing during that time. The Behrenstrasse, while it was close to Unter den Linden, was also close to the ill-famed Friedrichstrasse. I did not understand their concern. Because I often went to museums and galleries nearby, I simply said that I frequented 'öffentliche Häuser', which meant buildings open to the public – but, it turned out, also brothels. They burst into wild laughter.

When they had a work that needed confirmation of the artist, I was sent to take it to the Kaiser Friedrich Museum, to the then famous head, Wilhelm Bode. There were often queues outside his rooms, and when you at last got an audience he would write you a sort of certificate confirming his opinion. I also met Max J. Friedländer, the head of the department of prints and drawings in the museum. It was the custom for art dealers in the

Eva, her hair cut short in the 'Bubikopf' or bob, holding a catalogue

1920s to obtain certificates from scholars. Russia and Germany were very much in need of turning art into money, and the situation became quite exploitable. Buyers had to protect themselves as best they could.

The Rosenbergs frequently invited me to their charming home in the Bendlerstrasse in the Old West area of Berlin beside the Landwehrkanal. Today all that is wiped out.

A colleague from Graupe had become a great friend. His name was Ernst Jutrosinski. Apart from being a German philologist, music was his great love. We often went to concerts and got unnumbered cheap seats at the Philharmonic Hall. On Sunday mornings we listened to the rehearsals of the concerts which followed on Monday nights. In those days many great conductors performed in Berlin – I heard Furtwängler, Bruno Walter, Kleiber, Kussewitzky – and also pianists and singers. Artur Schnabel and Edwin Fischer became my great heroes. I sang in the choir of Siegfried Ochs, who ran the Oratorienschule of the Staatliche Akademische Hochschule für Musik. We performed the St Matthew Passion, the St John Passion, and much else. Ochs was an extraordinary person, and his performances of Bach were as dramatic and wonderful as a Verdi *Requiem*. (When I later heard the St Matthew Passion at the Royal Albert Hall in London I nearly walked out. It sounded very flat, a kind of dull church music.) Ochs had a wild temper, and one day referring to somebody who had not turned up at the previous rehearsal he shouted, '*Sie können ja mal fehlen, aber Sie können nicht mal kommen!*' (One can be absent occasionally, but you can't even be present now!). A woman in the front row of the choir wishing to appease him offered him boiled sweets, which he promptly in a wild gesture threw into the choir.

Max Battke had died in 1916. My aunt Ada's second husband, Dr Rudolf Cahn-Speyer, was a well-known personality in Berlin musical life. He had founded the association of performing musicians, the Verbandt der Concertierenden Künstler Deutschlands, which concerned itself with the performing rights of artists and composers. I still have extensive correspondence between him and people including Klemperer, Nikisch, Krenek, Pfitzner, Lilli Lehmann and Humperdinck. Among their other friends were Max Reinhardt and Franz von Lenbach, who had painted my aunt's portrait.

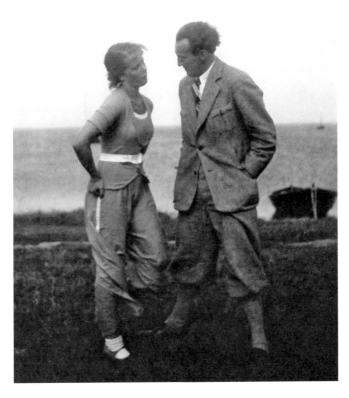

Jutro's mother had spoiled her three sons, and did everything for them. His father was a well-known doctor (*Sanitätsrat*), at whose table only learned conversation was permitted. If you didn't know who invented firearms or this or that, the relevant encyclopaedia had to be consulted immediately. The sons, in opposition naturally, used me, and I cooperated to demonstrate my utter ignorance. He was too polite to comment on my lack of knowledge, but asked Jutro after dinner to come to his consulting room. He told him that it was very heartless of him to make me realize how stupid I was and wondered why he had not noticed how I had been fighting back my tears.

At home in Tempelhof things were not so very different in this respect. My mother was extremely knowledgeable. Once or twice a week we had gatherings after dinner. Young friends came regularly, in particular my cousin Heinz Battke, Ada's son, who brought his own friends along. They all fell in love with Maja or Runi, both being very

Eva and her cousin Heinz Battke on the island of Hiddensee

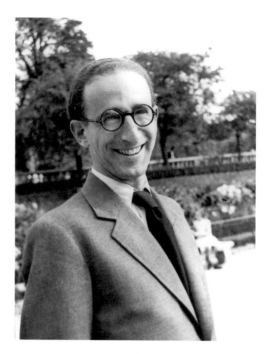

beautiful. One evening the conversation centred on Paris. 'Paris', said I, 'lies at the Sorbonne.' My mother nearly fainted.

Jutro and I wanted to marry. He had heard from his friend Fritz Landshoff, with whom he had been at the Mommsen Gymnasium, that an art dealer, J. Rosenbaum, was looking for a secretary, and the job promised double the wages I was earning at the time – was it of interest? Rosenbaum's large apartment in Viktoriastrasse was being refurbished by Ernst Freud (the son of Sigmund), who was a friend of Landshoff. I got the job and a very interesting time began. In the Twenties important collections were built up. Art dealers had a great time everywhere. Americans were eager to fill their museums, and of private collectors there were many. The company where I worked and a few other firms acquired some highly valued works and sold them to foreign museums and rich collectors. Great treasures passed through our hands – the *Welfenschatz* (Guelph Treasure) from Braunschweig, for instance. The clients were foreign museums and great collectors, among them Baron von Thyssen.

Jutro and I married on 23 June 1928. It was decided that we should have the attic floor in my mother's house. The wedding feast was great.

Ernst Jutrosinski in the Luxembourg Gardens, Paris, 1934

We had brilliant weather and the garden was at its most wonderful. A long table was set up in the big music room, decorated by Runi with gorgeous flowers. In the afternoon a brass band turned up from somewhere. All the neighbourhood participated, watching from their windows.

For our honeymoon we went to Austria and spent a week at the Mondsee. I was utterly flattered to be addressed as 'Frau'. Soon it turned out though that Jutro was quite useless in all practical matters. Back at home at dinner great discussions and rivalries between him and my mother filled the air. He also ordered the maids around, never asking my mother first or considering what others might want. It did not take long, just about a year, before we wished to separate. Our few belongings were fairly shared, and I went in search of rooms for him. We became best friends again for ever after.

At the end of the 1920s we had great fun during Carnival time. Fancy dress balls began already in January, usually on Fridays or Saturdays. There was the Akademie Ball, the Künstler Ball, the Bauhaus Ball, and more. One made one's own costume, often thin and transparent – good at the ball but cold in the icy winter air. The Akademie was used from top to bottom with music and dancing on all floors, so one spent the whole night upstairs and downstairs, here and there. Some of the artists' studios were open too, kept more or less dark, though, and around the walls there were people sitting or lying, naturally in pairs. I guess everybody drank a lot. I fortunately did not need it: I was excited anyway. I met a good many writers and artists there, including Alfred Döblin, whose book *Berlin Alexanderplatz* had just been published. The ball I liked best was given by the Bauhaus. Their percussion band fascinated me, and they allowed me to join in. I was in love then with Rudi Arnheim, who wrote amusing articles for newspapers, was a film critic, and worked for the Left-wing weekly *Die Weltbühne*. Many interesting people contributed to that magazine, in particular Kurt Tucholsky, a political, satirical journalist much loved by all for his wit. Rudi was studying phenomenology under Max Wertheimer, a method of assessing unconscious phenomena as developed by Edmund Husserl. He later worked at the Film Institute in Rome, and from there went to America where he eventually became Professor of the Psychology of

Art at Harvard University and then Visiting Professor at the University of Michigan.

Most of the cabarets in Berlin used satires on the political scene of the time that were often highly amusing. I can still see Marlene Dietrich walking up and down the stage with another famous chanteuse singing '*Wenn die beste Freundin mit der besten Freundin . . . durch die Strassen latschen um sich auszuquatschen*' (When best girlfriends . . . saunter down the street together to have a good natter). I also saw Josephine Baker at one of the fancy dress balls. Those were the days when Christopher Isherwood lived somewhere near the Alexander Platz. Sally Bowles, the heroine of his book *Goodbye to Berlin*, is true to the spirit of those promiscuous, glamorous and extravagant circles. Jazz was quite wonderful in those early days, and wherever we found these bands in nightclubs or cafés we went to listen.

My colleagues back at Graupe's were rich society girls. It was considered more elegant to be occupied with art and books. Eva K. [a good friend] was very proud of her legs and amused herself by ringing telephone numbers at random, saying, 'Here speaks the girl with the most beautiful legs in Berlin – not Marlene!' Legs were news, so to speak, as the long pre-war dress was not yet forgotten. Eva K.'s family had a large villa in the Grünewald and I was invited to a ball there. I wanted to go, but I had no suitable dress. In the end a little black silk thing belonging to one of my sisters was chosen. It had been agreed that I was to call at another girl's house first. There in her room she stood in front of her mirror dressed in a slinky gold lamé dress, with matching gold shoes and gold ornaments in her hair. I felt very intimidated. When we arrived at Eva K.'s house I did something I had never done before. My mother had told me that when being greeted by the lady of the house I should kiss her hand. I did – and the poor lady withdrew her hand with a jerk. I suffered nightmares before the event, and after it.

Those were the days when one fell in and out of love, had an affair, broke up, started a new one. That was the style in the Twenties. If you kept yourself to yourself you were not 'with it' and people considered you dull. I met Wilhelm Feuchtwang at one of the balls. He was very good-looking, and danced very well, but paid little attention to me.

Seeing him dance with other women made me wild with jealousy. I was seriously in love this time. One evening at a dance, however, I committed a terrible sin. Talking about music, I said, 'Oh no, I don't like Mahler, he's too Jewish for my taste!' Wilhelm more or less left me standing right where we were, in the middle of the dance floor. I had not meant to be anti-Semitic, but he, a fierce and proud defender of Judaism, took it very badly. (That was not to be the end, however.)

Money was always short after the inflation years, and what my stepfather contributed to the household was very irregular. Always full of ideas, my mother decided to start an art gallery, and called it 'Der Parthenon'. She rented premises on the Kurfürstendamm. Many artists came to the gallery, and also to our villa in Tempelhof. It was a very interesting and lively time. However the business was unsuccessful, and the space had to be given up. Now she organized exhibitions in the Tempelhof house. I remember her taking visitors around who approved – or disapproved – of the art on show. Seeing the heads of Nefertiti and Amenophis IV [in replica], they condemned them as 'too modern'!

One day in Tempelhof my mother's brother, Uncle Karl, came to visit. Whatever their conversation was about I don't know. I only heard loud voices – his and hers. He had joined the Nazi party, and he turned up his lapel to show her the *Hakenkreuz* – the swastika – and shouted that he was not going to tolerate these Jews in the family any longer! My mother, terribly upset, showed him the door, not to see him again for years.

Anita and our mother had problems with each other. Anita practised the piano for hours every day and deeply resented having to do housework: washing-up was bad for her hands. Our mother did not see it that way. She decided one day to have Anita's hair cut short, on the model of the great film star Asta Nielsen. As a result my poor sister had to suffer a great deal in school, street children mocked her, and my dear Uncle Heinz went so far as refusing to be seen in the street with her. Soon, though, this hair style became the new fashion of the Twenties, as the 'Bubikopf', the bob, took over.

Refugees poured into Berlin from Russia and we much enjoyed their cabarets, their restaurants and their films. Out of Russia came Sergei

Eisenstein's films *Ten Days that Shook the World* and *The Battleship Potemkin*. I was so totally swept away by the film about the October Revolution in Petrograd that I found myself together with the rest of the audience standing up, clapping and shouting.

Something similar had happened to me one day when I came out of my office at Rosenbaum's in the Viktoriastrasse and went towards the Landwehrkanal, but got no further: a huge crowd was blocking the road. I had to wait, but did not know what was going on, and nobody else seemed to know either. Suddenly great shouts rose up, and a car came into view with a man standing in it and waving his hands in all directions. It was Charles Lindbergh, who had just made the first solo non-stop transatlantic flight between New York and Paris in May 1927. I shouted like everybody else, although I did not know who he was. Suddenly with a shock I realized the grotesqueness of the situation and pinched myself hard to stop myself from shouting. It had dawned on me what mass hypnosis can do – so much in evidence a little later when Hitler came into power.

Jutro had friends in Italy. It was arranged that I was to go on alone first and he would follow later (although in the end he didn't). In Florence someone was to pick me up and take me to a farm in the hills called Coltaccio that belonged to a woman writer. Naturally I had to travel the cheapest way possible, in fourth class, a kind of cattle class. It took something like twenty-four hours, I believe. When we reached Bolzano I heard my first Italian words, '*Gelato, gelato!*' We reached Bologna at midday. It was July, and the heat was incredible. My carriage was shunted off to a side track where it stood for hours in the sun waiting to connect with another train much later. I was alone and very miserable.

A few days after I arrived in Coltaccio, my hostess announced that a friend from the other side of the hill in Fiesole was coming. I sat on a bench under a huge linden tree in the cobbled courtyard and saw him coming on his horse in a white shirt, up and down the hillside. He arrived, tied the horse to a post, and soon we were sitting together on the little bench. He spoke English, was blond and very beautiful. I did not speak English, and did not think myself beautiful. He wanted me to get onto his horse. I had never been on horseback before, and was wearing high-heel

shoes and a skirt. I put one foot in the stirrup (to my despair my skirt slipped down), and was to swing the other leg over the horse. With one high heel on the cobblestones and him trying to lift me up with his hands on my behind I slipped right under the horse, one foot still in the stirrup. My foot hurt terribly and he helped me back to the bench saying one thing again and again which I did not understand, 'I'm so sorry, I'm so sorry'. After that he came every day, massaged my ankle, and put fresh bandages on. At the end of my holidays, being in reasonable shape for walking, I went by tram to Florence for the first time. I visited the Uffizi – it was totally empty! I did not like the early Florentine and Sienese schools, but the Botticellis were more familiar. Then I found myself in front of a large painting, an *Adoration of the Shepherds*, and was deeply moved. The painter was Flemish, Hugo van der Goes, a Northern artist, not Italian. The next day I travelled home and was so glad to leave the blue sky, the cypresses, and all that unbearable heat behind. During the night I stood in the corridor and looked at the moon, and when the train reached the north of the Alps, entering Germany with its fir trees, I was happy.

Good things – Wilhelm Feuchtwang and Stephan – and bad

IN 1933 THE REICHSTAG WAS SET ON FIRE. It was blamed on a mentally handicapped Dutchman called Lubbe, who was later convicted in a big show trial. Hitler thereafter was given dictatorial powers by Hindenburg and the Nazi regime came into full force. More and more powers were assumed by Hitler, and the political and racial cleansing began. Musicians, writers, artists, all had to register at the newly established Reichskulturkammer. Some got permission to continue work, others were refused. Many of our most famous German artists were among the condemned whose pictures were taken off the walls in museums and galleries. (Goebbels eventually organized an exhibition called '*Entartete Kunst*' – 'Degenerate Art'.) Writers and actors had a desperate time, and many of the intellectuals left Germany for France, Holland, England and America. Musicians and painters experienced fewer problems abroad than those whose art dealt with words. It is difficult to express yourself adequately in a new language. However Thomas Mann, Heinrich Mann, Franz Werfel, Alma Mahler, Bertolt Brecht and others went to California. Jutro left Germany for France. I remember seeing him off at the Charlottenburg station. After the train had pulled out I was challenged by two Nazi brown-shirts saying that a nice girl like me should not have anything to do with those filthy Jews (Jutro looked very Jewish). From time to time he came back to Berlin. We were great friends, but finally in 1933 we wanted to get a divorce. Neither of us had enough money to pay the lawyers, so they acted for us through *Armenrecht* (legal aid). All went off successfully. Jutro, when later visiting Berlin, came to my office at Graupe's, now in the Budapester Strasse. We went to a nice garden restaurant for lunch. There our two lawyers who had divorced us were sitting at a nearby table. They saw us and couldn't believe their eyes.

opposite: Eva in her twenties

Our grounds for divorce, after all, had been '*unwidersteh-liche Abneigung*' – unbearable aversion – and now we were seen evidently to be quite fond of each other.

Our cousin Richard Wagner came visiting one day. We never liked him much because we thought he was stupid. He had made a great study of astrology, and produced a horoscope for each of us. We did not believe in them. When he told me that I ought not to marry Wilhelm – something I was considering at the time – and should never have a child, and that things would end badly, I naturally ridiculed it, swearing to myself that I was going to prove him wrong. As things turned out it was not altogether wrong. He had put it in writing, and a curious situation arose years later. The house in which my sisters and mother lived in Berlin was bombed, and the furniture was being let down from a window; a drawer of a chest opened and out fluttered a piece of paper – the horoscope. Much of what he had prophesied had indeed come true. Poor Richard was murdered by the Nazis because he had predicted Hitler's bad end.

Wilhelm Feuchtwang and I were now free. But the next big problem arose. His father, the prominent Chief Rabbi of Vienna, was liberal in intellectual matters, a great friend of Schnitzler and of some philosophers in Vienna, but that did not influence his religious views. The idea of his son marrying a non-Jewish woman would have been abhorrent. We decided to ignore it all and simply live together unmarried – not usual in those days.

Anti-Semitism became more intense daily and I felt compelled to make a decision. Was I going to be on the side of the Jews or on the side of the non-Jews? It seemed impossible to identify with the Nazis. Loyal to my father or loyal to my mother? I felt strongly drawn towards those who needed defence and were attacked and despised. My mother, when she first heard of my intention to convert to Judaism, felt betrayed by me. Here was I, intending to become Jewish because of the Orthodox intolerance of Wilhelm's family, when her life had been devoted to tolerance and freedom from prejudice. She felt and said that any orthodoxy was a great danger and evil in this world and that the Jewish demands and intolerance were no better than what the Nazis were about. But

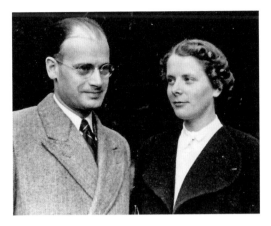

I converted to Judaism. I had to learn Hebrew, and the Jewish community through some kind of ceremony accepted me. Wilhelm Feuchtwang's brothers and sisters did not. They insisted that I underwent a far more Orthodox procedure. In the ritual bath, when my head came above water again I saw three male heads in the doorway, no doubt to check that everything was properly carried out. I found it very funny and was reminded of Rembrandt's painting of Bathsheba and the three elders. Wilhelm and I married on 2 November 1934.

Graupe's had become the most important auction house in Germany. They occupied the large galleries and rooms of the former Künstlerhaus in the Budapester Strasse, close to the Potsdamer Platz, and all the great art collections were put into their hands. I much enjoyed working as their assistant with the museum directors, cataloguing the material. One day Göring came and I was amazed at the unbelievable intensity of his smallish piercing blue eyes. The tightening of the Nazi regulations in all cultural fields had caused many to leave the country, and Paul Graupe did the same. He put Hans W. Lange in charge, my colleague and great friend, who ran the company from then on and later made it his own.

For our holidays Wilhelm preferred the mountains, while I thought I could only enjoy the sea. However, I soon shared his preference. We had the most wonderful weeks around Bad Aussee. I was fitted with some special mountain shoes which had to be hand-made. We went off with a guide on a few days' walk to the Dachstein. We swam in the lakes, and we spent the nights in a hut lying on the floor with many other people, side by side like sardines. At 4 o'clock in the morning we had to get up and start climbing. When we came to the steep rocks we had to take off our walking boots and replace them with small flexible climbing shoes. It was my first experience of climbing a mountain and I

Eva and Wilhelm Feuchtwang

was very excited. Going up with one's hands and feet seemed like good fun. The three of us were on a rope, the guide first, me in the middle, and Wilhelm last. On we went, when suddenly it became extremely narrow, about 1 foot wide, and I slipped. I fell and fell and was hanging on the rope. The guide must have fastened Wilhelm and himself securely so as not to have been pulled down after me. Supporting himself against the rock he slowly pulled me up. When I reached his little platform we were desperately panting for breath. There was only just room by the side of his feet for mine, and I can't recollect now how we were able to turn round in order to find the next foothold. Climbing continued, however frightened we must have been, until we reached the summit. There we were told that the climb down was even more risky. Yet I was so full of happiness that I did not think it hard, until we reached a large snowfield and a glacier. Instead of walking down the side in the snow, I was allowed to sit on my behind and slide down in a wild tempo. It went on and on, very fast. Then we walked across the flat ice field, when suddenly we found ourselves in front of a large crevasse. The guide jumped across and, with Wilhelm and myself attached to his rope, insisted that we jump too. There was no other way. Wilhelm did. I could not. They coaxed and persuaded but I could not. They assured me that even if I missed I would still be attached to the rope. At long last I gathered my courage to jump, and did not fall into the crevasse.

I had not yet met my parents-in-law, and at Easter it was decided to visit them in Vienna. Pesach – Passover – is one of the highest Jewish festivals in the year and its celebration around the family table is of particular significance. The story of the exodus from Egypt is read out from the Haggadah and the youngest at table asks the oldest what it was all about. I had to learn that in Hebrew because I was the youngest. Evening starts when three stars are visible in the sky. Everything was prepared in the kitchen, when my mother-in-law discovered that little paper doilies for the glass plates were missing. I frantically offered to run out to buy some, before the evening stars had come up. Feeling euphoric about escaping, I rushed downstairs, taking three or four steps at a time, marble steps, and on the last one I slipped and fell! I was lying there for at least a quarter of an hour in total agony until the porter discovered

me and informed the family upstairs. The doctor was called and I was bandaged. I was very unhappy to have made such a mess of things.

The next morning my father-in-law, as Chief Rabbi, was called away because a notorious baroness had died. She was well known for her great wealth, occupying a huge floor in the Imperial Hotel and engaging, they said, the services of something like forty lawyers. This woman was the mother of Dr Cahn-Speyer, the husband of my aunt Ada. I was nearly out of my mind. It meant that Ada was in Vienna with her husband, and my father-in-law would now ask them personal questions about the family to prepare his speech at the funeral. It would become evident to him that I was not Jewish by birth. My brothers- and sisters-in-law had always feared that such a discovery might cause him a heart attack. I wrote a frantic letter to Tante Ada imploring her not to mention me. However,

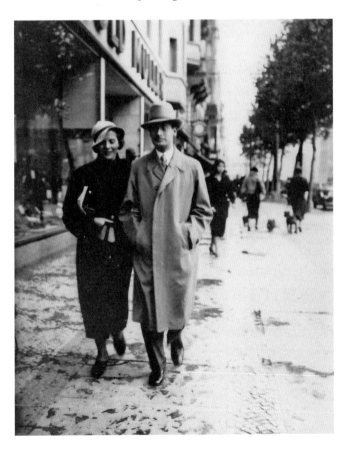

Eva and Wilhelm Feuchtwang

my father-in-law's eyes rested on me at times with a curious expression. He was a wise man, though. My aunt and uncle disinherited me. They felt, not altogether wrongly, that I had betrayed my mother.

We were to spend New Year of 1936–37 in Bad Aussee. Wilhelm was on a business trip [he was working as an agent for a corporation that bought industrial firms and restructured or closed them down] so I went on ahead. On 31 December I got a telegram saying he would come a few days later. I was deeply upset. I felt something terrible would happen if he wasn't with me at New Year. I could not stop crying all day, and my hostess could not understand my unhappiness. She said, quite rightly, that a few days would not make that much difference, and all this desperation seemed so unlike me.

One day in February 1937 Wilhelm asked me to meet him for lunch at the Hotel Adlon in Unter den Linden. It was all very pleasant, and when we came out into the brilliant sunshine he said, 'If I should not come home tonight you will have to inform my solicitor and do precisely what he says in every respect.' With that he went off and did not come back. He had been arrested, and there was no way of knowing where to contact him. Thus the most harrowing experience of my life had started. The solicitor was unable to find him, and the dreadful uncertainty of what might happen to Wilhelm haunted me day and night. One knew only too well of the tortures. The thought was devastating. Day after day I sat in the solicitor's office hoping for news. Eventually I was given the name of the prison and his number and was permitted to write to him. Each letter took a good time to reach him, but I did get replies in tiny handwriting. He was only given one small piece of paper but managed to fill it with a lot of information and messages. Naturally these letters were censored. On 17 March two men came to search our home. They seemed pleasant, young, and while they looked through every scrap of paper nothing disagreeable happened. They took me to the Alexander Platz, the famous police headquarters of Berlin. I was not arrested and was allowed to go home. My relationship with the solicitor became tense, and only Wilhelm's instructions hindered me from leaving him. Cheerfully he kept saying, 'Oh, don't worry. We don't have to do anything yet. I will make my defence speech at the trial and that will be quite enough.' He went off to Africa on safari.

Apart from my family I had very few contacts, because wherever I went the Gestapo followed me and tapped the telephones I used. Wilhelm's uncle, Dr Dunner, was the only person I saw frequently. He much supported me but naturally was frightened himself. When eventually another solicitor was recommended to me I handed the case over to him, in spite of Wilhelm's strict instructions before his arrest, with a frightened heart. Things became at least psychologically more bearable. Then I discovered that I was pregnant. I wrote to Wilhelm, told him, and had his wonderful reply. So the weeks of tension and fright combined. Then one day the solicitor telephoned, 'You can pick up your husband in the Black Maria tomorrow morning at 8 o'clock.' The extreme shock and unexpectedness of it all – there had been no sign of such a possibility – almost caused me to lose my child. Dr Dunner insisted that I should stay absolutely still in bed. I did not. It would have been unthinkable not to go to the police station to meet Wilhelm there. He had been let out on bail, and friends lent me the money required.

From then on we had to move around from day to day, night to night, because the Gestapo were pursuing Wilhelm. His arrest had been on legal grounds, but the Gestapo pursued him for their own reasons. Every night we slept in friends' apartments, hardly ever going home. My sister Anita shared our flat at No. 9 Adolf Hitler Platz. One morning I had gone home and Anita had obtained some duck eggs for our lunch. As a result both she and I got desperately ill with paratyphus. We had temperatures well above 40° C. However, she could stay in bed there while I had to keep moving around from place to place. Eventually though I had to stay at home and risk whatever might happen. My main concern was that I might lose my child. On Saturday morning Anita accused me of trying to prevent her from taking over my work at Graupe's. This was far from the truth, because being heavily pregnant I could not have worked anyway. I was outraged and deeply upset by the quarrel, and at about 11 o'clock on Sunday morning the contractions began. Off we went to hospital, but my doctor was away on holiday: it was after all some three weeks sooner than expected.

It had been my great wish to be fully conscious at the birth of my child. I did not want anything to deprive me of this so vital experience.

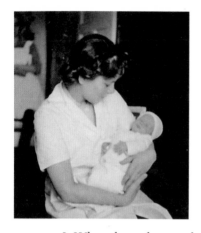

The pain became unbearable after some fifteen hours, but the night nurse had no instructions to give me painkillers. So it went on and on for the whole of the night and the whole of the next day, Monday. At last, at about 7 o'clock on 8 November 1937, Stephan was born. I collapsed, having lost much blood, and no-one, not my sisters or my mother or Wilhelm or anyone else there, had the same blood group as I. When the end seemed close, all were called in to say goodbye to me. I was unconscious. When I woke up I noticed someone lying at my side and a tube connecting my right arm to hers. A nurse who had come back to work – somewhat drunk as I was later told – had the right blood group. Next day I was strictly told to keep absolutely still. I did not know why, but the fact was that a blood clot had formed in my lung and any movement might have caused the clot to wander on, causing immediate death had it reached the heart. After a few weeks I was allowed to go home, but had to stay in bed for some time. A nurse looked after Stephan, whom I was not allowed to feed.

In January 1938 Wilhelm's trial began. Seven people had been accused of breaching the embargo on foreign exchange. Wilhelm had insisted on standing trial to prove his innocence. It was sheer torture for us both, he as the accused, I as an onlooker, during the procedure of twelve hearings between 25 January and 24 February. At every session one of the accused was found guilty and taken away, until at the last Wilhelm was left the only one sitting on the bench. He was released due to lack of evidence.

On 13 March 1938 Hitler marched into Austria. Wilhelm had Austrian nationality, a fact that, no doubt, had prevented the Gestapo from seizing him. The news had come with the midday papers. Our passports were valid for two more days. At 9 o'clock in the evening we took the last train to Holland. The next morning at 4 o'clock the Gestapo knocked at our home and terrified my sister and her husband. However, we had gone.

Eva and the infant Stephan, 11 December 1937

We were wonderfully received when we arrived in Rotterdam. Erica, Wilhelm's sister, took care of the baby, and we were introduced to our new quarters, in the house next to theirs that she and her husband Bernard Davids (who was Chief Rabbi of Rotterdam) had rented for my mother-in-law, who had joined them after the death of her husband in Vienna in 1936. They were most kind to us and helped in every way. For me, much as I loved them all, it was not easy living closely together with my Orthodox Jewish mother-in-law. She was not to know that I had had no Jewish upbringing, and this proved to be a dreadful burden. I learned how to cook kosher, and after a while I couldn't imagine how anyone could add cream to a meat gravy (according to Jewish law meat must never be mixed with milk). I felt homesick, and Wilhelm was struggling desperately to obtain a permit to enter England. We had to register regularly with the police, for whom we were simply foreigners who should return to their own country. The terror repeated itself every two weeks. One night I collapsed and fainted. For three days I lay unconscious. It was I think largely due to my brother-in-law's influence and the great esteem in which he was held by the police and the Dutch community that we were not sent back, and on to the gas chambers.

Erica looked after me wonderfully, and knowing about my love for music booked us tickets to a concert. For all the time that I had been away from Berlin there had been no music. The pianist Lili Kraus was a pupil of Schnabel, and she and Simon Goldberg played the Kreutzer Sonata. I began to feel ill; my heart was going wild and I thought that I was going to faint again. We were sitting in the third row from the front and in wild desperation I rushed to the nearest door – big iron doors. I wrenched them open. The cold wind nearly blew the music off the stand. I found myself outside. Erica had followed. I thought I could never survive this shocking experience.

Eventually in March 1939 Wilhelm got a permit and we set off for England.

Perhaps I should mention here that when the Nazis marched into Holland they swept up all Jews and put them in the concentration camp of Belsen. It is strange to think that my mother-in-law, Erica, and her two daughters survived the years of horror, while Bernard and his son died.

Three of the 'Britain in Pictures' books conceived by Adprint and published by
Collins. English Country Houses *appeared in 1941,* Life Among the English
in 1942, and English Cities & Small Towns *in 1943*

London, 1939–1949: introduced to Adprint

In London at first we stayed in a bed-and-breakfast hotel. While other people think the smell of bacon is the most delicious smell to wake up to, it made me feel sick. A really good English breakfast consisted then of porridge, followed by bacon, eggs, grilled tomatoes, baked beans and fried bread, or haddock, followed in turn by white bread toast with jam or marmalade. You could have coffee or tea as you wished. It fuelled you for the rest of the day.

My sister Maja had left Germany for London before we did and was living in an apartment house near the Abbey Road. Luckily we got a flat just below hers, a one-room flat with a small extra room for Stephan and a tiny bath and kitchen. Wilhelm got us nice antique furniture – a bench, a cupboard, a carpet, some chairs and a table. I was often alone in our new apartment because Wilhelm had to travel a lot for his work. Shopping was difficult because I couldn't speak English: what I'd learnt at school wouldn't penetrate all the Dutch still in my head. Kilburn High Road amazed me with its lining of stalls displaying fruit and vegetables from all over the empire – things I hadn't ever seen before. There was a Woolworths, and all the pre-war songs blared out from radios – Vera Lynn, Gracie Fields, 'We're gonna hang out the washing on the Siegfried Line'. It was bewildering, and although my sister was around I still felt isolated and lonely. I particularly remember a very depressing Sunday afternoon, walking for hours with Stephan in the pram down the Harrow Road. The area was not exactly slummy, but dull and monotonous, with never-ending rows of houses.

The political atmosphere during that summer of 1939 was tense. However my mother insisted on visiting us on Maja's and my birthday in August. It was unbearably hot. The streets were hung with banners

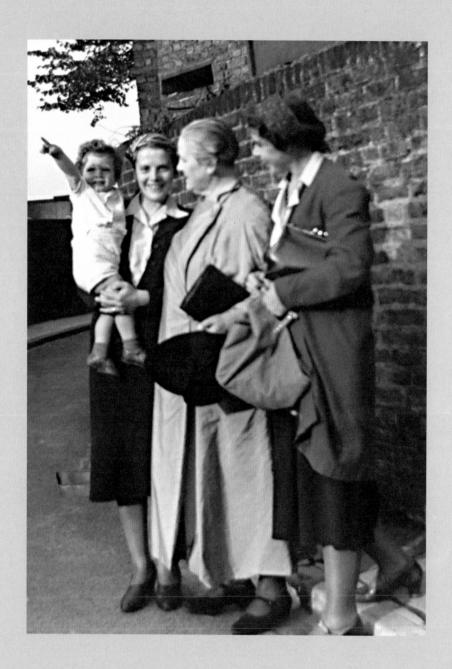

Stephan, Eva, Muttl and Maja in London, August 1939

saying, 'We have got to be prepared'. Gas masks were distributed. Corrugated iron air-raid shelters were dug in people's back gardens (the majority of people in London then had small houses and gardens, and the few living in apartment blocks were to go to their basements). At the end of August the situation became threatening. My mother had to return to Germany: she was not going to stay in England, having two daughters still in Berlin. She had a terrible, harrowing journey. It was chaos on the railways, with troop movements and preparation for the war to come. On 3 September 1939 Chamberlain, who had not long ago come back from Munich with his great slogan, 'Peace in our time', was now declaring war on Germany, prompted by Hitler's invasion of Poland. It was a Sunday, and when evening came we heard the first howling siren. Wilhelm had Stephan on his arm, and seeing a large moon Stephan said, 'Oh! The moon is singing!' Children were evacuated into the country, away from cities. There were heartbreaking scenes between them and their parents. Wilhelm and I decided that I should go to Cambridge, where I knew a lady whose husband, the Austrian ethnomusicologist E. M. von Hornbostel, had died a few years earlier. It was a charming house and she was delightful company. However the so-called 'Phoney War' had begun and after some time I went back to London.

All foreigners were now to be classified. We were called to a magistrate for interviews. He asked polite questions: 'Do you like it here? What do you think of England? Would you like to stay here?' This civilized behaviour was very touching and a bit unnerving. It was odd after having escaped death by the skin of our teeth. Wilhelm and I were put in class C, which meant we were OK. Class B were people who were OK but with some reservations. Class A were under suspicion of spying and were imprisoned. The classification changed from magistrate to magistrate and from county to county. They were out of their depth in trying to understand the background of these aliens. Various methods were used; many people were rounded up and shipped off to Australia or Canada, and their experiences were often dreadful. The disaster of the *Arandora Star* which was sunk by a submarine was one of the terrifying rumours circulating. Although we had all been classified, after a time the Government got very nervous and established internment camps on

the Isle of Man. In some streets people were arrested and in others not. I think when women had children they were allowed to stay. The police came to us and Wilhelm was taken away. I was alone, with my child and no money. I couldn't pay for food, let alone pay the rent. Friends came to my rescue. One was Rudi Arnheim, who intended to go to America, the other was Lisa Thenen.

I knew Lisa from skiing in Bad Aussee. By some curious coincidence she had heard of my being in London. I was about to accept a domestic cleaning job so that I could earn some money and have a roof over our heads when her telephone call came. 'Come to tea', she said, and described how to get from West Hampstead, where I lived, to Highgate, walking across Hampstead Heath. She lived at No. 1 Holly Terrace, in a charming flat that had been modernized by Ernst Freud for his brother Martin Freud, who was Lisa's lover. Martin had been interned on the Isle of Man too. I did not have to take my domestic job, and moved with Stephan into her flat. We had a jolly good time together, and a friend of hers, Grete von Schrenzl, joined us. The house was at the top of Highgate West Hill, and had a lovely view over London. Now war was starting in earnest. The financial centre, the City, was attacked by incendiary bombs and from our high hill we could see the immense fantastic fire. Hitler had evidently thought to terrify and demoralize the population. In fact nobody was hurt other than a few cats. Most people in London don't live in the area where they work, and certainly in those days not in the financial centre. Huge areas were destroyed, however, and it was to take some twenty years or more to rebuild the City.

In June 1940 France fell to the Germans and the evacuation from Dunkirk caused the Prime Minister Winston Churchill to appeal to the United States for military supplies. The Germans occupied the Channel Islands and intensified their air attacks on British cities. The Battle of Britain raged right through 1940 and did not end until June 1941, when Hitler marched into Russia. When it was getting dark the sirens sounded and everyone rushed home from work. The bombs fell right through the night until the all clear sounded in the morning. We all took our turn at fire watching.

During that winter I wanted to visit Wilhelm on the Isle of Man, and I got permission from the police to travel to Liverpool. Sitting in the train opposite me was an Air Force man who tried to start a conversation. I resisted, but in the end told him what the purpose of my journey was. My English was very halting but he got the point. When we arrived everything was pitch dark, as it was blackout time. Had it not been for him I cannot imagine how I would have managed. He took me to a hotel and the next morning picked me up again. I had forgotten to report to the police, which was required of aliens if one moved away from the place where one was registered. My Air Force friend explained and pacified the policeman, and then put me on the boat. The camp was divided into groups of houses and I was allowed to talk to Wilhelm for an hour or so. Lots of famous people were there together – not only Martin Freud, but musicians such as the Amadeus Quartet, scientists, historians, and scholars. They organized lectures on many varied subjects and altogether I think they did not have a bad time.

Walter Neurath, also from Vienna, had been in the same camp as Wilhelm, but was released after only two weeks. He was the director for books in a company called Adprint and had started a series called 'Britain in Pictures', of which the first title was published in 1941. The Ministry of Information regarded these books as splendid propaganda material and Walter was released in order to continue producing them. Walter had arrived in Britain in 1938 with his wife from Vienna, where he had been a publisher of illustrated books, in particular a series for children. He had commissioned from Dr Ernst Gombrich a history of the world and a history of art.* 'Britain in Pictures' was published by William Collins. In England paper was rationed; publishers who had been active before the war got their quota, so it was necessary to have a company like Collins to share their paper quota and their distribution services. The subject matter covered every possible aspect of British

* The former, *Weltgeschichte: Von der Urzeit bis zum Gegenwart*, was published in Vienna in 1936, to great success. The latter had a different history: Gombrich was invited to lecture in England and took the half-finished manuscript with him. When war broke out he could not return. The manuscript was later published by Phaidon and became a world-wide bestseller, *The Story of Art*.

life: British seamen, British women, British novelists, British soldiers, etc. The authors were well-known writers, and the essays they were asked to write were not to exceed 10,000 words: all had firm contracts with other publishers, and it was the shortness of the essays that made it permissible for Adprint to commission them. The books were attractively designed, and the subjects were documented by illustrations in the text. The success of the series was amazing.

Walter, when he was back in London later in 1941, visited Lisa and me, bringing greetings from Wilhelm. He invited me to have lunch in a restaurant. For me this was tremendously exciting and glamorous, although in fact it was a simple little Swiss place in Charlotte Street, where there were other Continental restaurants too. Walter proposed that I should join the staff at Adprint. Wilhelm had joined the British Army rather than spend all the war years in the camp, and wives of British soldiers were allowed to take on any employment they wished: I accepted the proposal. I worked on the 'Britain in Pictures' series, learned how to make layouts, and was also sent out to do picture research.

The raids on London became intense. Whole streets were destroyed. Stephan was in another part of London at a nursery school, while I was in my office in a small street just off Oxford Street. Our flat was not far from Primrose Hill, where anti-aircraft guns were positioned. The noise combined with the bombs from the sky was deafening and horrible. We had no shelter, but there was one right next to us in a mews. Up to then both Stephan and I had braved the raids. I never wanted to go to the underground tube shelters, although many people did (as recorded in Henry Moore's *Shelter Sketchbook*). On one night we dived out under the exploding sky and stood with our next-door neighbours in their shelter. It was full, but they let us stay there, until somebody said, 'Why don't you go back to your Germany? Why don't you have your own shelter? There is no room for you here.' I left, taking Stephan, and rushed back home. The flat we were in had a tiny lavatory extending out into the garden and Stephan said, 'These walls, Mummy, they will stand up. Don't worry, it is quite safe here.' This was too much for me, and I decided to send him to a school in Shropshire, Bunce Court.

While the success of 'Britain in Pictures' continued and the books were translated into many languages, other illustrated projects got under way. A photographic studio was installed. I was working on children's books for the under fives, for Collins. Photographs were taken partly in the studio, but if the story required it we went 'on location'. I remember one time when we went to a seaside resort where I also took Stephan to model as one of the characters in the story.

After the end of the war we considered publishing ourselves. The relationship between Walter and his managing director, Wolfgang Foges, was not the best. The firm was financed by a City company, Tennant and Co., and it was Lord Glenconner who dealt with us. A friend from Vienna living in America wanted to start publishing there and came to London to learn from us what he could. His name was Paul Steiner, and in collaboration with Adprint he founded the Chanticleer Press. When Lord Glenconner visited this young New York enterprise Steiner was outraged that his shirt cuffs were frayed at the edges: he thought it was an insulting attitude, and assumed that a lord thought he need not bother about his appearance in America. But while Americans had plenty of everything, we were all on rations in England, and lord or not one couldn't buy new shirts when one needed them.

The finances at Adprint took a bad turn, and new funding was sought from Tennant's. It was a situation that Walter for various reasons much mistrusted, and he thought of freeing himself as soon as he could.

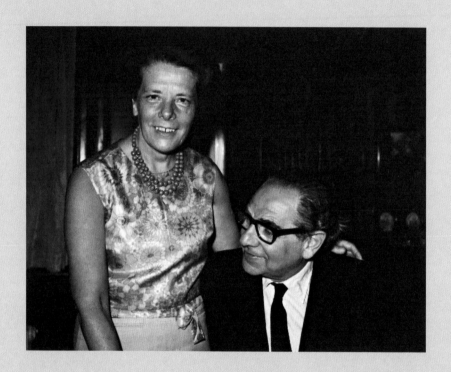

Eva and Walter Neurath at home in Highgate in the 1960s

Walter Neurath, and Thames and Hudson

IN THE SPRING OF 1949 Walter and I went on holiday to Cagnes near Nice, and that is, if I may call it that, the birthplace of Thames and Hudson. While he left Adprint immediately, I stayed on for another half year.

Walter went to America to talk to Lady Margesson. She had been the wife of Viscount Margesson, the Secretary of State for War, and Walter, when he arrived in England, had been invited with his wife to stay at their country estate, Boddington. After their divorce Lady Margesson went back to America with her son Frank. She was prepared to finance an American company provided Frank took part in it. Here in the UK Walter got a printer, John Jarrold, and an engraver, Wilfred Gilchrist, to contribute £1,000 each, and he himself put in as much as he could. We did not pay ourselves salaries at first: the money was needed for paying bills. In the English language 'Neurath' would not work as a name for a company, and someone made the suggestion to call it 'Thames and Hudson'. It did indeed properly describe our circumstances – the names are those of the rivers of London and New York – and had the added advantage of sounding like personal names. In the autumn of 1949 Thames and Hudson was incorporated in London, and, at about the same time, in New York.

While I was working with Walter at Thames and Hudson, my relationship with Wilhelm became strained. We had already lived separately because of the war, and this separation was now recognized as necessary by both of us. He had taken up his business connections again but had very little money at his disposal. Nearly all the expenses connected with Stephan, such as his school fees, had to be borne by me. Stephan's school in Shropshire was closing down, and I had enrolled him at Bryanston School, but he loved Bunce Court and wanted to stay as long as he could.

A year later the place at Bryanston was no longer available, and I had no school for him. In 1948 Wilhelm and I were divorced. From 1948 to 1951 Stephan boarded at Sherardswood in Welwyn Garden City while I searched for another school. Kurt Hahn's famous school at Salem in Germany had been evacuated to Scotland in 1933, along with many of his pupils (including the future Duke of Edinburgh). This kind of Continental school seemed to me suitable, but the Gordonstoun fees were high. By some lucky coincidence, they had opened a new house and were prepared to charge only part of the ordinary fees, so Stephan started life there at the age of fourteen. I was not often able to visit him: the journey up to Elgin was very long, and for my finances difficult. But I kept in constant touch, of course, not only with him but with the school.

Walter spent much of his time in New York, while I stayed here in London. Communication between London and New York was not what it is today. One tried to catch the right aeroplane in the hope that the letter would arrive within twenty-four hours, but it often did not because of local postal deliveries. So we had to rely on telephone calls, often under agonizing conditions: voices fluctuated, and no matter how much one would shout, one had a hard time understanding or making

In the Margessons' garden at Boddington: on the left Stephan; then a little neighbour; on the right, Marianne Neurath with Constance and Thomas

oneself understood. However, decisions had to be made on the London side of Thames and Hudson for which I really needed Walter's approval or guidance. Often his calls came in the middle of the night, and I ended up screaming down the line. At the end of one call, I remember collapsing into hysterical weeping.

The New York company was short-lived. Frank, totally inexperienced, always needed to go to what he called his 'thinking room', from which he emerged with no particular results. He was a nice young man; I can still hear him saying to someone on the telephone when he was in the London office at 244 High Holborn, 'Oh, it is easy to find, just opposite the public lavatories.' Walter had to disentangle the relationship with Frank's mother, acquired all the shares, and from then on we concentrated on the London firm.

After the war the whole of Europe felt desperate to build itself up again. Expert that Walter Neurath was in printing and in art, being an art historian himself, we got commissions to produce books for the Museum of Modern Art, the Metropolitan Museum, and the newly established publishing house Harry N. Abrams, all in New York. Harry, after having left the Book of the Month Club, intended to become the most important art book publisher. When at a party he met Oskar Kokoschka, he asked him whether he had ever heard of somebody called Walter Neurath who lived in London, because he very much wanted him to cooperate with his new enterprise. 'No problem!' Kokoschka might have said, 'he is a very good friend.' And so our cooperation with Abrams began. These American orders were vital for bringing in cash. It takes a long time from commissioning a text to getting the final product into the shops, and the money from sales came in slowly. Gradually more and more of our books got on to the market. They were initially distributed by another publisher, Constable. Our first book, in 1950, was *English Cathedrals*, with photographs by Martin Hürlimann, of Atlantis Verlag in Zürich. From then on we published all his photographic books.

Thinking back on the war years I had great difficulties coping with my feelings for Germany. Understandably, most of the refugees had reason enough to welcome the raids there. For my part I had watched with horror the squadrons of aeroplanes on their way to the Rhineland:

Düsseldorf, Cologne – beautiful cities flattened. I hated Churchill's remark about a bomb attack on Milan, 'Let them stew in their own juice.' It was not only because my family was still in Germany. Confronted with the horrors of Hitler's regime, I found the whole situation was quite unbearable. I had to come to terms with my origins. I started a Jungian psychoanalysis, which lasted for many years. More than one session a week I could not afford, and when Stephan came home on holiday I had to break off. I was deeply fascinated by Jungian psychology. His theory of the collective unconscious, the mythology connected with it, gave Walter and me the idea to publish books influenced by his thinking. We went to Ascona where the Jungians held their annual conference in August. The scholars who gave papers there came from all over America and Europe, and many became our authors. It inspired us to start a series in 1952 under the editorship of Jacquetta Hawkes, 'The Past in the Present'.

Archaeology began to captivate the minds of many in those days, not just in England, and another series, 'Ancient Peoples and Places', was started under the editorship of Glyn Daniel. The contributors were all authorities in their field. Over a hundred titles have so far been published, and the series is alive to this day [1981]. No other series of archaeology books had the same validity and importance.

Three generations, after the war: Runi, Anita, Maja, Lotte, Muttl,
Eva and Stephan

In the 1950s and '60s we published a great many large books, beautifully illustrated. The basic economy of such books rests on international cooperation. The cost of printing large images in colour and black-and-white is too great to be borne by a single publisher in one country. If, however, there is also an American, a German, a French, a Spanish, and a Japanese edition the cost per unit naturally goes down considerably. The text was usually not very long, and was printed on separate paper; for foreign editions, it was produced by the publisher in question or by us. In Germany we worked with Droemer, in Italy with Mondadori, in France mainly with Arthaud, and in America chiefly with Abrams. We produced these books in England, or elsewhere in Europe – in Holland or Switzerland or France, wherever we could negotiate top quality at the best price. Production costs in America were enormously high by comparison.

Walter and Eva after a tour of the harbour in Rotterdam

In 1950 Walter's wife suddenly died of a heat stroke in Austria. He was left alone with two young children, Constance and Thomas, and although friends were very helpful he wanted to establish a new home. On 6 August 1953 we were married. In search of a house, we travelled in our car for days and weeks and nothing seemed right. One evening, coming back from Tottenham in north London, we went down through Highgate where Walter spotted a 'For Sale' sign. I refused to move, being exhausted and fed up. He went alone and came back full of enthusiasm for the house he had seen from a small private road called Holly Terrace. The next day we got the agent to let us in, and straightaway fell in love with the house. I had stayed at No. 1 Holly Terrace with Lisa Thenen during the war, and now we were going to buy No. 6. It seemed a very pleasant coincidence.

Art publishing in England had always been rather inconspicuous. Certainly here and there books on art and art history appeared, but it was still rather innovative and indeed risky to produce illustrated, finely printed luxury books. Topographical books printed in photogravure (a technique not used much these days, as the process is slow and therefore expensive) also had a most appealing look. So it did not take too long for our name to become established, both among booksellers and among the discerning public. We felt encouraged, and Walter had the idea for a new series of books which he called 'The World of Art'. They were of a handy medium size, hardback, jacketed in black with a picture on the front, and priced as low as 35 shillings (£1.75). They were initially produced for the English market only. To make the price possible

Eva and Walter Neurath on 6 August 1953, their wedding day

large quantities had to be printed, and royalties consequently to be kept low. Walter wanted to bring art to the people, and believed that to write even a relatively short text only the best scholars were suitable. The success of the series grew and grew, and Allen Lane (founder of Penguin) considered Thames and Hudson to be providing a service to the reading public in terms of art books similar to what he was doing with Penguin. A generation or two have been influenced and informed by these very economical and instructive books. The whole spectrum of architecture, design, music, painting, sculpture, artists, and periods in art history has gradually become available. Prominent at first were books on important museums such as the Louvre in Paris, the National Gallery in London, the Metropolitan Museum in New York, and the Prado in Madrid. Also hugely successful and popular were Herbert Read's *Concise History of Modern Painting* and *Concise History of Modern Sculpture*. Some 400 titles have been published since the series began, and at present [in 1981] about 130 are in print. Our publishing houses in New York and Paris – Thames and Hudson Inc. and Editions Thames & Hudson – took the series on, and there too it has proved most popular and successful.

From a small company with our first offices in the attic at 244 High Holborn we moved in 1954 to a Georgian house at 30 Bloomsbury Street near the British Museum, a traditional publishing area. While we

Walter, Muttl and Eva on 9 August 1953, a few days after the wedding

were working on our then most important series of books, the 'Great Civilizations', special rooms, in fact a house, had to be hired round the corner in Great Russell Street. It did not take long though before the house next door, No. 32, became available, and the two were then connected floor by floor.

Henry Moore was the subject of a brilliant book by Herbert Read in the 'World of Art' series; we also published books on his sculpture, and a study of his drawings by Kenneth Clark. I frequently visited him and his family in Much Hadham. He was a wonderful man, with great sensitivity in all matters of art and vision. At home he lived a very simple, almost frugal, life with his wife Irina. All his success, and probably wealth, had not changed him at all. He was filled with intense enthusiasm and had the most engaging charm. To be in his company was a real experience. When we worked on his book of drawings I had the great benefit of listening to his comments on how various substances worked in space, and more. He did not draw only in preparation for sculpture, but did a great

A sales conference in the early 1960s: from left to right Glyn Daniel, Wilfred Gilchrist, Eva and Walter, Trevor Craker and Alena Knapp

deal of general sketching. When in the last years of his life one of his legs did not allow him to stand and do sculpture, he sat in his conservatory, which had a wonderful view over the low, long hills, with his sculpture of *King and Queen* visible in the near distance, and made sketches of sheep. The animals came up close to the glass walls, nosily looking in, and later we published a lively book of these sketches called *Henry Moore's Sheep Sketchbook*. We saw a great deal of one another also in Italy, where he had a little house in Forte dei Marmi by the sea and we had a house further up in the mountains. He came to dinner, and he and Walter talked about the greatness and yet insufficiently appreciated art of Giovanni Pisano. After Walter's death, Henry Moore very much wished a book to be published on Giovanni Pisano, and so it was organized. He had chosen a photographer from Carrara, and Michael Ayrton became the author. We all went from Pisa to Pistoia, Siena, and other places containing Giovanni Pisano's sculptures. Henry Moore in his plimsolls hopped around the figures explaining in his vivid English Italian to all concerned how the sculptures should be seen and photographed. The Italians there could not understand a word, but everybody understood his meaning. It was an exciting, wonderful experience for us all. *Giovanni Pisano: Sculptor* was published in 1969.

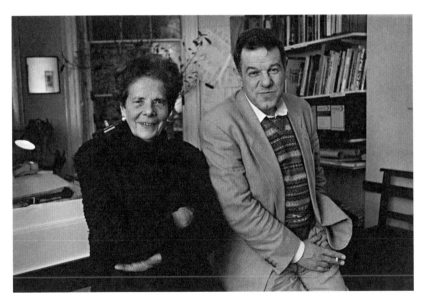

Eva and Thomas in the art department at 32 Bloomsbury Street

Walter Neurath had died on 26 September 1967. He was buried near our home, in the historic Highgate Cemetery. The loss of Walter's guidance and leadership seemed to be an overwhelming problem. But the staff gathered around the family and actively set to work.

Walter's son, Thomas, still in his twenties, had closely assisted him for some time. It was of great help to me that Thomas's sensitivity to Walter's methods and ideas was so much alive. Because I had been there from the beginning and was a founder member of the company it seemed natural to all that they should elect me chairman and Thomas managing director. He and I worked closely together for many years, until I felt that it would greatly benefit him were he left more to himself and so further his individuality and independence. Gradually, over the years, I withdrew into special projects, but continued to participate in administrative matters.

In 1981 Glyn Daniel, our editor of the 'Ancient Peoples and Places' series, retired from his professorship at St John's College, Cambridge. Coinciding successfully with this was the publication of the 100th volume in the series, his *A Short History of Archaeology*. The Prince of Wales, who had studied archaeology as a pupil of Glyn Daniel at St John's, wrote the introduction to a Festschrift called *Antiquity and Man*, which we also published for this occasion. A party was arranged at one of the guildhalls in London. Guests had to arrive no later than 7 o'clock, when all doors had to be closed. Sniffer dogs were employed before the arrival of HRH. He came and sat down on one side of Glyn Daniel, and Thomas Neurath, who had also studied archaeology under Glyn Daniel, sat on the other side. The Prince made a speech telling what it had been like to be under the tutelage of this great scholar, and indeed how much fun it had been for him. Then Thomas stood up and talked not only about his student time but very much about the great contributions Glyn Daniel had made to Thames and Hudson and the world of archaeology by being the initiator and now famous general editor of the series. Scholars from all over the world had been invited to contribute on very specialized aspects of archaeology, and its unique authority had become greatly appreciated internationally. After the speeches we all moved out, keeping at some distance from HRH, into another room where drinks were served.

Everybody was to leave before the Prince – yet I somehow remained behind. He took me by the hand and drew me through the long halls, joking and laughing all the way.

We now [in 1981] occupy five houses in Bloomsbury Street, and have a staff of about 110, representing in uneven numbers our various departments – editorial, design, picture research, sales, publicity, and administration. Our distribution is handled by another fully owned company, Thames and Hudson (Distributors). In Australia we incorporated a new company in 1964. Our foreign sales staff has greatly increased. International publication is and always has been the heart of Thames and Hudson.

Tiles at the entrance of 30 Bloomsbury Street, based on the design, by Reg Klein, of Thames and Hudson's original logo (photographed in 1981)

Afterword

by Stephan Feuchtwang

I think this memoir was spurred by questions that Eva's granddaughters had begun to ask her. They were prompted by my mother's frequent, almost habitual, references to the 1920s as times when anything was possible and most things tried later had already been done. In addition, I think she also wanted to record how Thames & Hudson was founded and how much it had been her life's work. The memoir ends in 1981. But Eva's work in and for the firm continued until 1999, the year she died. So I feel the need to add a few things to amplify some of what she wrote, and some things she did not write, to bring us up to the end of her life.

Eva was a last, fifth, daughter of a formidable mother – as she has strongly and explicitly conveyed. What she has left implicit is her sense of being the youngest and always in danger of being left out. Perhaps the combination of admirable, principled and avant-garde mother and being the youngest of a set of five sisters is what made her so alert, even competitive, and eventually the equally admirable and formidable woman that people encountered in her Thames & Hudson years. But she was always also highly conscious that she had no schooling beyond the age of fourteen, that she was entirely self-taught, whereas her older sisters had full schooling and vocational education. This adds poignancy to her memory of the fiftieth birthday celebration of her father, when her uncle Heinz and two

Stephan and his first daughter, Cordelia, 1961

of her sisters jumped out and frightened her as she was rehearsing the lines of her part in the play Muttl had written for him. When he was fifty, on 26 December 1911, she was only three years old. Her older sister, Lotte, in the memoir she wrote for her own children, remembered the event thus: each girl had her own part in a five-verse song near the end of a long operatic play about the life of their father. Each had to present her own character as seen by their mother. But Eva could not sing her verse, so the four sisters sang it for her. Lotte implies that Eva was too young to sing her own part. Had she been too scared by their interruption of her rehearsal?

The story adds an edge to what she must have felt when at a reunion near Bregenz, where Runi then lived, for Eva's sixtieth birthday in 1968, the sisters passed on a deeply unsettling disclosure: they told her that in their favourite cousin Heini's opinion she could not have been the child of their father, because in 1908 when she was born his syphilis was already quite advanced. They guessed that her biological father must have been Karl Hallbauer, the husband of Martha, their father's sister. Was that why he had asked Muttl whether he could adopt her, when she was a girl? (Muttl had asked Eva if she wanted to be adopted by him. She did not, and that was the end of that.)

Her wide knowledge of the fine arts was the result not of any formal education but of her work for an auctioneer and art dealers in Berlin, and then later in London as picture researcher, designer and art director – all learned on the job. It was a great joy to visit churches and museums with her. She found ways of describing what she saw and responding to it that impressed everyone. In one of the obituaries she is remembered as having never used a cliché. Perhaps this is because all her knowledge was based on practical experience. She often reminded us that she had no university or art school foundation. I suppose

Miranda and Cordelia Feuchtwang, 1961

she could and should have been proud of this, but it was always an admission of a sense of lack.

During the war as a refugee in London, separated from my father, Wilhelm, who was interned in the Isle of Man, she was deeply depressed and at her wits' end. Walter Neurath had also been interned there but only briefly. Released to continue his publishing of books for Adprint, he came to visit Eva in London with an orange for me as a gift from my father. Their relationship must have begun then with this act of friendship. Walter offered her a job in Adprint. From this low point on, she found a place to recreate herself in her own right. Adprint's 'Britain in Pictures' series was a pioneering development in design, printing, and publishing. It was also a patriotic project, securing Walter's release from internment. But this must have given Eva more than one awkward moment. For one thing there was her mother's pacifist anti-nationalism, of which she would have been reminded when Muttl visited London in 1939, returning to Berlin a few weeks before Britain declared war. In addition, she proudly identified herself as German. On one of the many Saturday evenings when my wife Miranda and I dined with her at Holly Terrace Eva told us about the morning after the bombing of Dresden: coming into the office and hearing the triumphant tones of the staff relating the raid from the news, she said she felt appalled at the destruction of the beautiful city, part of her German heritage, and she kept her distance from their celebration. Many years later, just before the dismantling of the wall that brought a unified Germany back into existence, she told us how much she regretted the neglect, by historians of art and other historians, of Central Europe, that huge cultural area to which she had belonged and still identified as her own. (Further east lay what she characterized as 'peasantry'!)

At Adprint of course she also fell in love with Walter. Exchanging a loving but somewhat subservient relationship with my father for a loving, more equal but still second-fiddle relationship with Walter in the founding of Thames & Hudson left her a lot of room to develop her own style and skills.

During holidays from boarding school, I lived with my mother at our home in London. My father, after he was released from internment and

then from the army, was there every evening after work, leaving only after I had gone to bed to go to his own flat. They kept up this relationship, despite the pain her separation in favour of Walter caused. It must have been some time after her divorce from my father in 1948 (about which I knew nothing) that she asked me one bedtime how I would like to have a sister and brother (Constance and Thomas) and whether I would support her marrying Walter. As she had been asked by her mother whether she wanted to be adopted, so she in turn asked me whether I would accept her marriage to Walter. I did. They married in 1953, and soon afterwards I lived with them and Walter's children, my new stepsister and stepbrother, in the house she and Walter had together found in Highgate.

Their child was Thames & Hudson, born in 1949 with the help of the printer Jarrold and the blockmaker Gilchrist. The staff Walter and Eva employed were also heavily committed to it, and so it has been that as the firm has grown into one of the largest publishing houses it is still a family firm. Among the dedicated staff for well over forty years until their retirement are Emily Lane, the editor of this memoir, and Shalom Schotten, its designer. I too worked at Thames & Hudson, but only part-time, in 1963–65, to earn my way through a master's degree at the

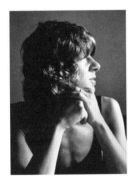

London School of Economics, learning to edit and do picture research and, directly from my mother, how to correct colour proofs against colour transparencies called ektachromes or against the original works of art. It was fun, but I wanted to do my own research and writing as an academic, and I knew I would not in the long run be able to work for my mother and Walter.

Thomas and Constance, less bothered by the family dynamic than I was, were fully committed to work at T&H, and kept the family firm thriving and growing. Thomas, as Eva recounts, took over as managing director when Walter died, with Eva supporting him as chair of the board. Constance became head of the design department about 1968, leaving Eva to pursue book projects of particular interest and her active role as chair. Constance it is who initiated this publication of Eva's memoir, some years after her own

Constance Kaine, photographed by John Kaine, c. 1970

retirement. Thomas's elder daughter, Johanna, joined the design department (of which she was to become head in 2004), and one of her first and finest productions was the book published on and for the fiftieth anniversary of T&H on 17 June 1999, *Vision: 50 Years of British Creativity*. The National Gallery that evening was the scene not only of T&H's triumph but also a great occasion for Eva, sitting in splendour and being attended by so many of the authors and staff she had nurtured. It was a beautiful midsummer evening, as Miranda and I paused with her in the portico on leaving, to look into the luminous sky beyond Nelson's Column.

Of course we did not know that this would be the last year of her life. But it was fitting. She was tired and beginning to become ill in August at the time of her ninety-first birthday, which Miranda and I spent with her. Her health declined in the months after that. She had to undergo an operation from which she did not really recover, and she was readmitted to hospital in December. She was however determined to have Christmas Eve surrounded by her family as usual, including her grandchildren and great-grandchildren, just as she had enjoyed it in her youth in Berlin. From a desolate low as a refugee, she now had around her bedside with whom she could drink a celebratory glass of champagne not only Thames & Hudson but also her step-family – Constance, and Thomas and Gun and their daughters Johanna and Susanna – and her own rather large family of Miranda and me, our daughters Cordelia, Anna and Rachel, and our grandchildren – Cordelia's Alex, Jamie and Rosie and Anna's Billy and Isaac (Rachel's Lotte and Maya had not yet been born, but Rachel had just been told that she was pregnant with Lotte, and confided that to Eva). She was not in the least interested in keeping alive for the turn of the millennium. Christmas was enough, and she died on 27 December 1999 at the age of ninety-one.

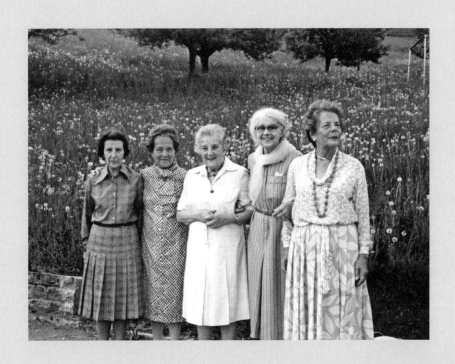

Anita, Lotte, Runi, Maja and Eva by the lake at Runi's in the 1970s

Family tree

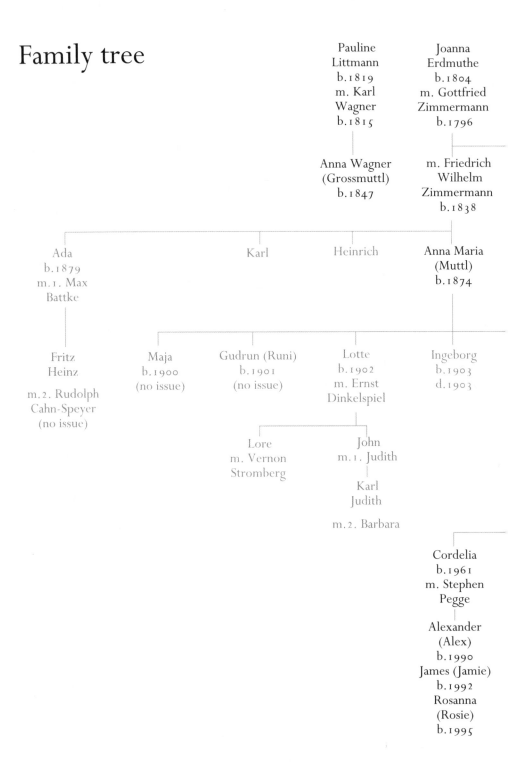

Pauline
Littmann
b.1819
m. Karl
Wagner
b.1815

Joanna
Erdmuthe
b.1804
m. Gottfried
Zimmermann
b.1796

Anna Wagner
(Grossmuttl)
b.1847

m. Friedrich
Wilhelm
Zimmermann
b.1838

Ada
b.1879
m.1. Max
Battke

Karl

Heinrich

Anna Maria
(Muttl)
b.1874

Fritz
Heinz

m.2. Rudolph
Cahn-Speyer
(no issue)

Maja
b.1900
(no issue)

Gudrun (Runi)
b.1901
(no issue)

Lotte
b.1902
m. Ernst
Dinkelspiel

Ingeborg
b.1903
d.1903

Lore
m. Vernon
Stromberg

John
m.1. Judith

Karl
Judith

m.2. Barbara

Cordelia
b.1961
m. Stephen
Pegge

Alexander
(Alex)
b.1990
James (Jamie)
b.1992
Rosanna
(Rosie)
b.1995

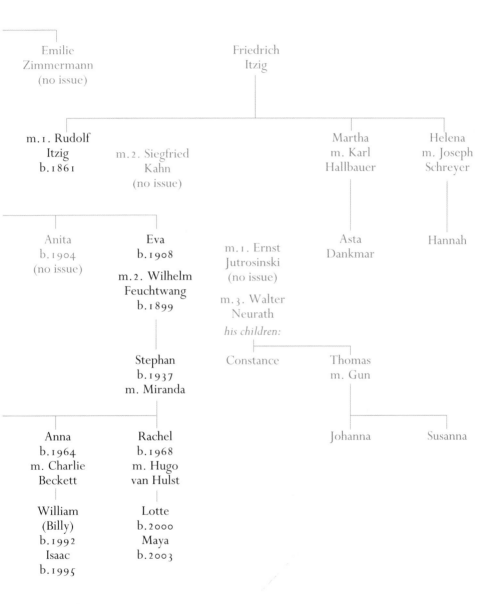

Emilie
Zimmermann
(no issue)

Friedrich
Itzig

m.1. Rudolf
Itzig
b.1861

m.2. Siegfried
Kahn
(no issue)

Martha
m. Karl
Hallbauer

Helena
m. Joseph
Schreyer

Anita
b.1904
(no issue)

Eva
b.1908

m.2. Wilhelm
Feuchtwang
b.1899

m.1. Ernst
Jutrosinski
(no issue)

m.3. Walter
Neurath

his children:

Asta
Dankmar

Hannah

Stephan
b.1937
m. Miranda

Constance

Thomas
m. Gun

Anna
b.1964
m. Charlie
Beckett

Rachel
b.1968
m. Hugo
van Hulst

Johanna

Susanna

William
(Billy)
b.1992
Isaac
b.1995

Lotte
b.2000
Maya
b.2003

Notes on the family tree

*The information that follows —
inevitably incomplete — is based on
Eva's documents, including some from
Maja and Anita; on notes taken from
conversations between her and Runi; on
Lotte's memoir, 'As I remember' (parts 1
and 3); and on my recollection of what
I, Stephan, have seen and been told.*

*Unlike the order in the family tree,
the people here appear youngest first.*

Eva Urvasi Born on 22 August 1908
at Louisenstrasse 1, Berlin-Lankwitz; died
on 27 December 1999 at the London
Clinic, London.

In a document of 10 May 1928
Anna Kahn (formerly Zimmermann) is
registered as Eva's guardian; they are at
the same address, Albrechtstrasse 103,
Berlin-Tempelhof. This probably marks a
return to her mother after being under the
guardianship of one of her father Rudolf
Itzig's close colleagues, Walter Rabow, a
director of Grauman & Stein. He helped
the family in many ways during the years
of extreme shortage after the death
of Itzig in 1915 and had become the
guardian of all the sisters.

She married Ernst Jutrosinski ('Jutro')
on 23 June 1928 in Berlin. He was an
antiquarian, librarian, and philologist; they
had met through work at the auctioneer
Paul Graupe. They divorced in 1933.
He remained a close family friend.

She then married Wilhelm Gottfried
Feuchtwang on 2 November 1934, in
Berlin-Charlottenburg. She had been
introduced to him by Jutro. One child,
Stephan, born on 8 November 1937.
All moved to the UK in April 1939. Eva
and Wilhelm separated in 1942 and
were divorced in London in 1948.

She then married Walter Neurath
on 6 August 1953, in Hampstead,
London.

Her five sisters, from youngest to oldest

Anita Ruth Born on 14 September 1904
at Taubenstrasse 23, Gendarmenmarkt,
Berlin; died in 1989/90 in Baden-Baden.

Worked as a piano teacher. She lived
with Hans Lampe (who had been tenant
of the second spare room let in the villa
in Tempelhof); they could only be married
after the war, because during the Third
Reich as daughter of a Jew she was not
allowed to marry an Aryan. Lampe was
a partner in a perfume business with the
Scherk brothers, and kept it going when
his Jewish partners had to emigrate. No
children. They lived in Berlin-Zehlendorf
in the house of Walter Rabow, who had
died in 1930. On retirement they moved
to Baden-Baden.

Ingeborg Eva Karolina Born on
2 October 1903 in Berlin; died on
30 October 1903 in Berlin.

Charlotte Mirjam ('Lotte') Born on
3 November 1902 at Taubenstrasse 23,
Berlin; died in 1996 in Croton-on-Hudson,
New York.

Worked as a bookkeeper, first for
the tailor brother of Walter Rabow, then
for 'Der Parthenon', Muttl's gallery, and
then for the doll- and mannekin-maker
Baitz, for whom Runi had gone to work.
Later, in London after her husband's
death, she worked as a bookkeeper for
Thames & Hudson.

She married Ernst Dinkelspiel, a metal
engraver, son of a kosher butcher, in 1928.
Two children: Lore, born in 1929 in Munich,
and John, born in 1935 in Dulwich, London.
They had moved to London after Ernst's
business partner became a member of the
Nazi Party and Ernst came under police
investigation in 1933. From Dulwich they
moved to Rochester, New York, where
Ernst worked for Kodak. After Ernst died
Lotte came back to London and worked
for some years. Then she returned to the
USA, to Croton-on-Hudson, New York.
John died in April 2013 in South Carolina.

Gudrun Rahel ('Runi') Born on 18 July 1901 in Schoenebergstrasse, Berlin; died in 2003/4 in Bregenz, Austria.

Studied at art college with her cousin Heinz Battke. She then worked for Baitz, the doll- and mannekin-maker, whose firm she looked after with another partner, Paul Friedel, after it was confiscated in 1938. (In 1942 Lilli Baitz, about to be sent to Theresienstadt, committed suicide.)

As in the case of her sister Anita, the man Runi would eventually marry had been a tenant (the first) in a spare room in the villa in Tempelhof, and they could not marry at the time. Walter Schemell played bassoon in the Berlin Philharmonic. He was conscripted. When the war ended he walked to join Runi in Austria, arriving emaciated and full of lice. The Baitz firm had moved to Bad Aussee and then Lustenau, and they married there. For many years they lived in Wiesbaden, where Walter was a musical director of Wiesbaden Opera. They then moved to Bregenz, where he managed Bregenz Opera.

Maja Elsbeth Born on 23 August 1900 in the old harbour area of Berlin; died in the 1990s in Bremen.

Trained as a photographer after the 1914–18 war and then worked for Heinrich Schulz's Deutsche Kunstgemeinschaft, organizing art exhibitions.

Schulz had been a neighbour and family friend when they lived in Berlin-Steglitz. He was much older than Maja; they married in 1932, the year he died. She remained close to his former wife, Mamie, until the latter's death.

In 1937 she married Martin Wiener, to whom she had been introduced by Jutro. In 1938 they moved to London, where Martin died in 1941.

She then married Fritz Borinski, a pioneering pedagogue and champion of adult education. They met in the Society of Friends (Quaker) Germany Assistance Committee, where they worked, and in the Lutheran church in London. At the end of the war the British Government asked them to return to Germany to help with the reconstruction of education. Maja started a school in Schloss Goehrde, while Fritz started a Volkshochschule, for adult education, in Bremen, where they went to live. Later he became a professor at the Freie Universität Berlin. On his retirement they lived in Baden-Baden. After his death Maja moved back to Bremen, and died there in a nursing home.

The girls' parents and the parents' relatives, and the girls' stepfather

Anna Maria Elisabeth Zimmermann ('Muttl') Born on 2 July 1874 in Altforst, Forst (Lausitz); died in January 1960.

Called 'Muttl' not only by her daughters but by many others, to whom she became a mother figure.

She was born into a Lutheran, 'Evangelisch', family but registered herself as 'dissident'. After she and Siegfried Kahn moved to Tempelhof she opened a gallery for indigent artists calling it 'Der Parthenon' in premises on the fashionable Kurfürstendamm, and then back in the villa, helped by better-known painters such as Käthe Kollwitz.

Muttl was married twice – in 1899 to Rudolf Itzig, and in 1917 to Siegfried Kahn.

> Her younger sister **Ida ('Ada')** in 1898 married **Max Battke**, composer and leader of a choir accompanied by lutes and mandolins, two of which were eventually played by their two sons, **Heinz ('Heini')**, who became a fairly well-known painter, and **Fritz**, both of whom were frequent visitors to Muttl and her daughters, their cousins. Fritz was induced by his patriotic mother to enlist in the 1914–18 war and was killed, for which Muttl could never forgive her. Ada divorced Max Battke during the war (he died soon after, in 1916) and married **Rudolf Cahn-Speyer**, whom she had got to know through Max, in Vienna. Cahn-Speyer inherited great wealth. He was also a composer, a

conductor, and both founder and head of the composers' copyright guild. They moved with Heini to Florence in 1933 to escape the Third Reich, but Rudolf was killed in an Italian concentration camp. Ada and Heini remained in Florence until she died.

Muttl's brothers, **Heinrich** and **Karl Zimmermann**, and their wives were close to her children. Karl had been supported by Rudolf Itzig, but he nevertheless joined the Nazi Party in 1933, and had tried to prevent Muttl's marriage to another Jew, Kahn, saying he had had enough Jews in the family.

Rudolf Itzig ('Vati') Born on 26 December 1861 in Berlin; died on 1 October 1915 in a nursing home in Bernau, Mark Brandenburg.

He was born into an Orthodox Jewish family, and although like Muttl he registered himself as 'dissident', he sent his three older daughters to Hebrew classes.

He designed coats and ran an agency for clothing makers.

> Rudolf's sister **Martha** married **Karl Hallbauer**. They and their children, **Asta** and **Dankmar**, were close to Muttl and her children. Heinz Battke later said to Runi that he thought Hallbauer was Eva's actual, though not registered, father, because by 1908 Rudolf's syphilis was too far gone, and Runi broke this idea to Eva during a visit in Bregenz on Eva's sixtieth birthday.

Siegfried Kahn Died in 1935.

Muttl's second husband. She was wooed very romantically by 'Kaensche', a senior lawyer for the UFA film studios in Berlin. They married in 1917 and had no children, but he offered the five sisters his surname in case they wanted to avoid the family name Itzig, which was an immediate identification as Jewish.

Anna Maria Zimmermann's parents

Anna Pauline Wagner Born on 4 October 1847 in Spreewald near Cottbus; died on 5 April 1935 in Berlin-Tempelhof, where she had lived in the top storey of the villa.

Friedrich Wilhelm Zimmermann ('Fritzi') Born on 14 April 1838 in Forst (Lausitz); died on 14 July 1892 at Paulstrasse 33, Berlin. A brewer.

> His unmarried sister **Emilie** eventually became the housekeeper of Ada Battke's household.

Rudolf Itzig's father and sisters

Friedrich Itzig Born in Seelow, Mark Brandenburg. A *Meister* of silk-covered fur-coat buttons.

> His daughter **Helene**, Rudolf's sister, married **Joseph Schreyer**, a financier. Anna Maria Zimmermann (Muttl) worked in his office, leading to her meeting Rudolf. Lene and Joseph Schreyer's daughter, **Hannah**, became a close friend of Lotte.
> Friedrich's other daughter, **Martha**, married **Karl Hallbauer** (see above).

Anna Pauline Wagner's parents

Pauline Louise Augustine Littmann Born on 7 November 1819 in Soran.

Karl Friedrich Traugott Wagner Born on 29 September 1815 in Cottbus.

Friedrich Wilhelm Zimmermann's parents

Johanna Christiane Erdmuthe Born on 11 February 1804 in Forst (Lausitz).

Gottfried Heinrich Zimmermann Born on 23 August 1796 in Neudamm.

DESIGNED BY **SHALOM SCHOTTEN**

EDITED BY **EMILY LANE**

Set in Perpetua and Gill Sans

PRINTED AND BOUND IN CHINA BY

C&C OFFSET PRINTING CO LTD